Colorful Portraits of Winter

book & photography by
Jodi Marie Fisher

all photographs taken in the Northwestern United States

Copyright © 2019 Jodi Marie Fisher
Photography by Jodi Marie Fisher

All rights reserved. This book or any portion thereof
may not be reproduced or used in any manner whatsoever
without the express written permission of the publisher.

Printed in the United States of America
First Edition 2019
Colorful Portraits of Winter

ISBN-13: 978-1090232199
ISBN-10: 1090232195

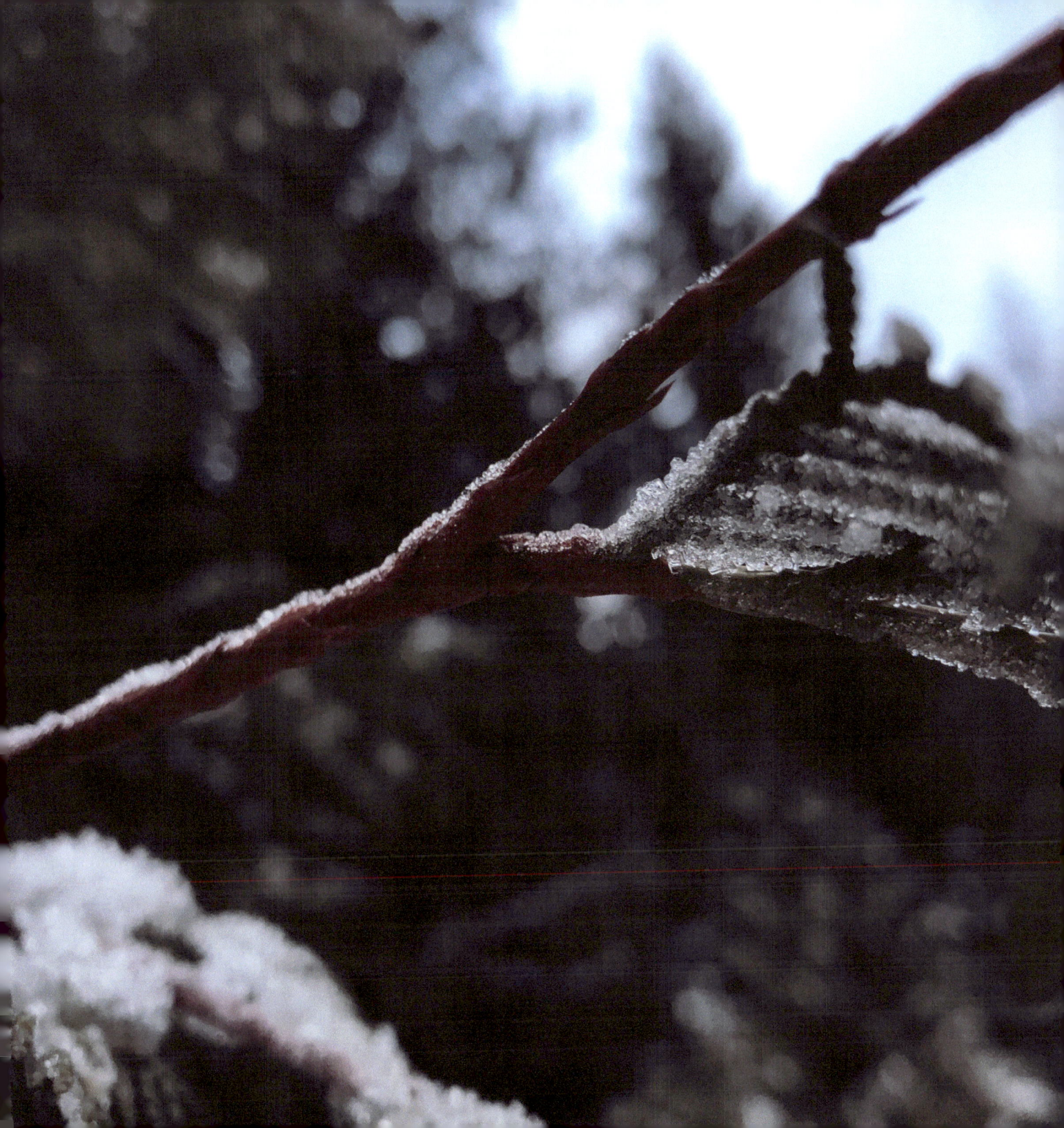

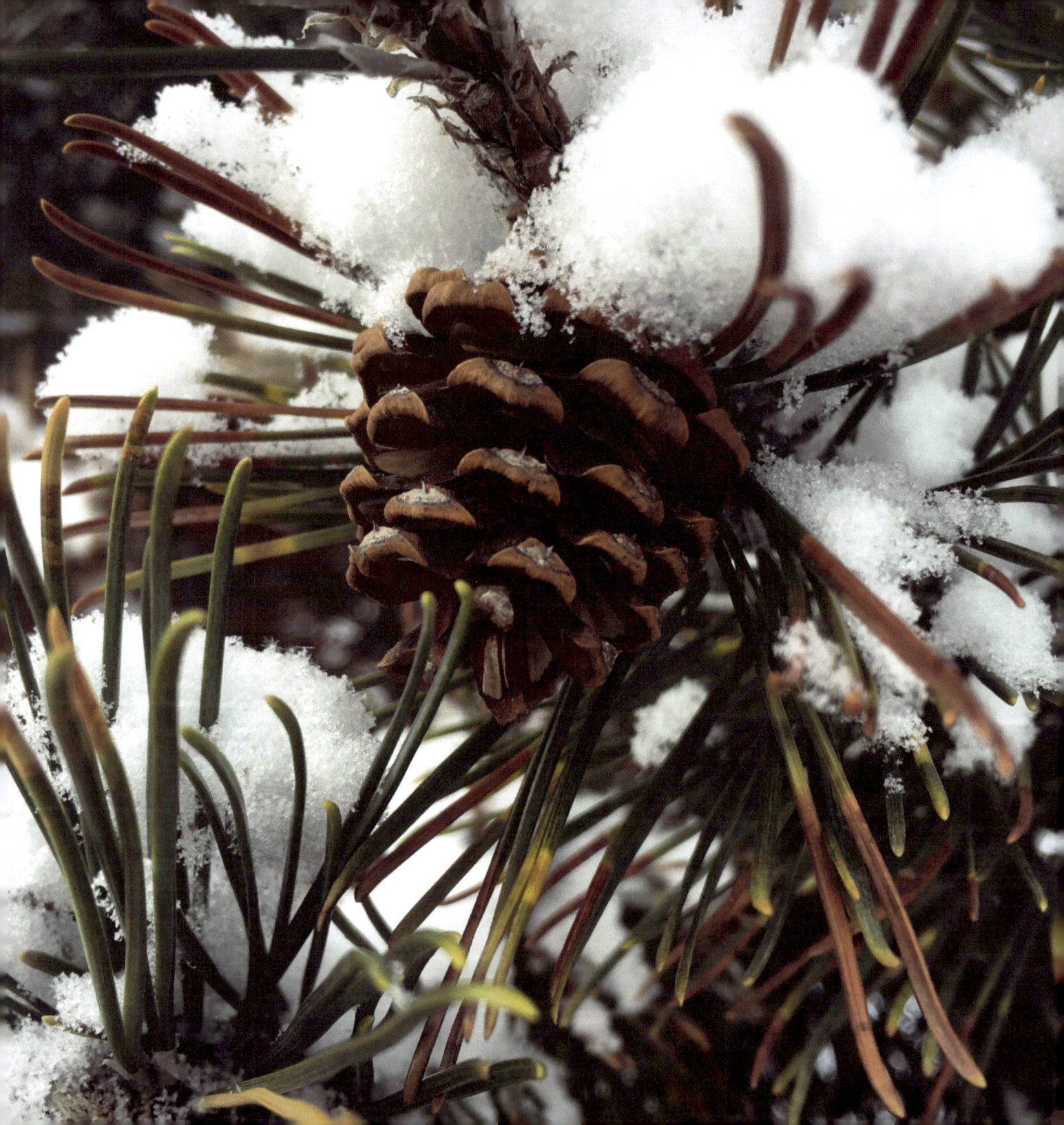

What are Colorful portraits of winter?

Seasons have portraits. **Faces. Personalities. Characteristics** you can recognize. When you see a familiar face. A family member. A friend. Even a stranger. Their portrait is distinct. Though some are similar and many almost the same, no one face is the same in people and the same is true in portraits of nature.

This book of colorful portraits of nature displays many, yet certainly not even close to all, of some of the faces you recognize in winter. Certainly the most distinct of faces we see in winter is marked by the cold. The snow. But there are many other faces that winter has to offer and I hope you enjoy just a few of them in the photos on the pages ahead.

These photos are a collection of a few different years' winters for me. The majority of these photos were taken on a normal day in different parts of the Northwestern United States. I didn't always plan to take them. I wasn't looking for these faces around me, but these faces found me.

When you look out at a winter scene, all you may see is snow or cold, a mountain, a tree, a forest, or a garden buried in a blanket of snow, but if you look closely, you will see some incredibly beautiful faces inviting you to appreciate the season.

Keep watch through these pages for winter characteristics in **pine needles**, **leaves**, **buds**, **berries**, **seed pods**, **snow**, **frost**, **bark**, **pinecones**, **sticks**, **branches**, **thorns**, **icicles**, and even **flowers**.

Then, open your eyes to see the colorful faces of nature around you in the season you find yourself in.

The more you look closely at the portraits of the seasons around you, the more I hope you will also look closely at the **faces** of the people around you and start to see that together we make up the **beauty** of life.

From beginning to end, these photos, in rainbow order, encourage you to appreciate the simplicity of nature's unique portraits and the joy they bring.

Thank you for picking up this book and experiencing these portraits together.

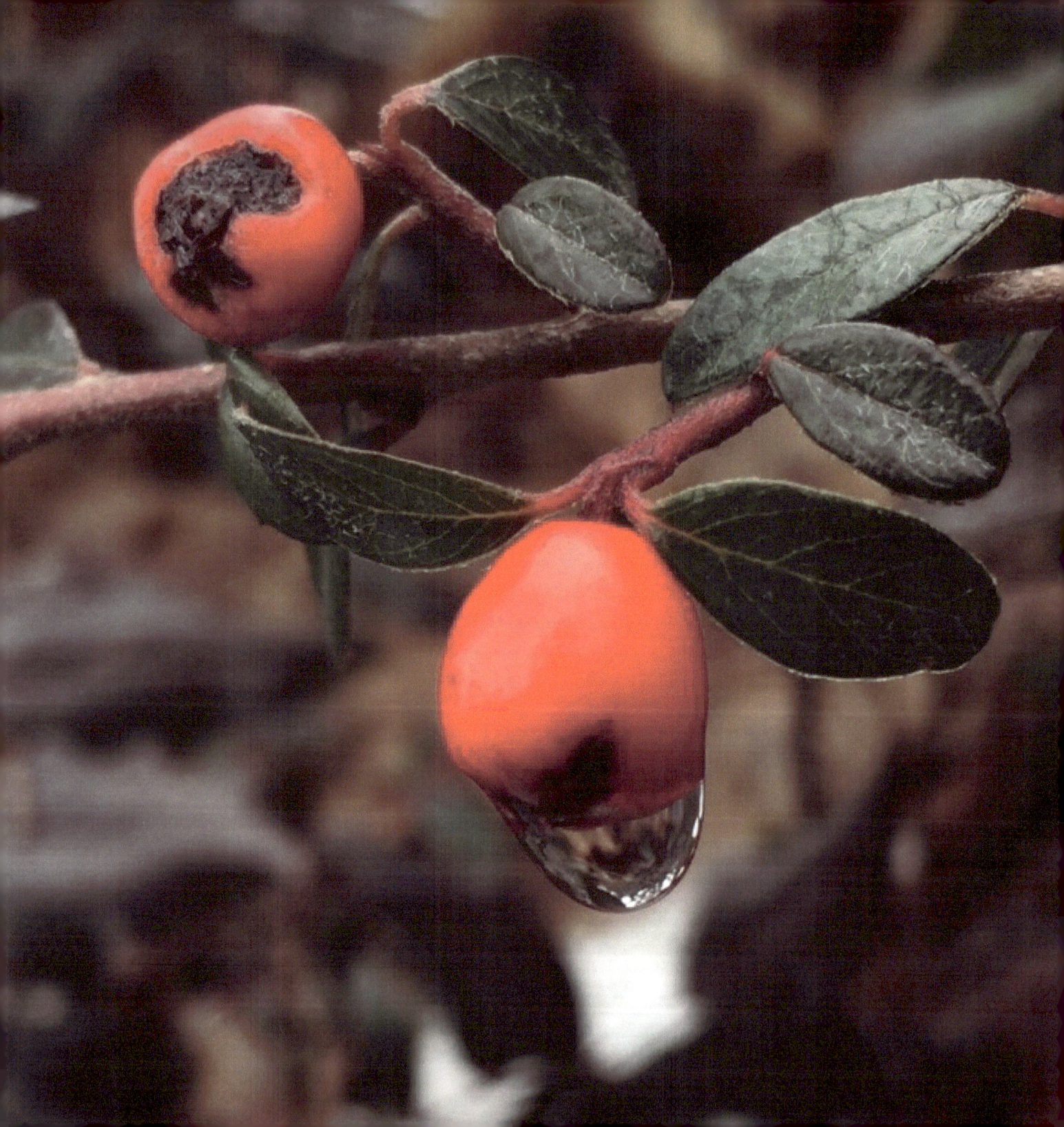

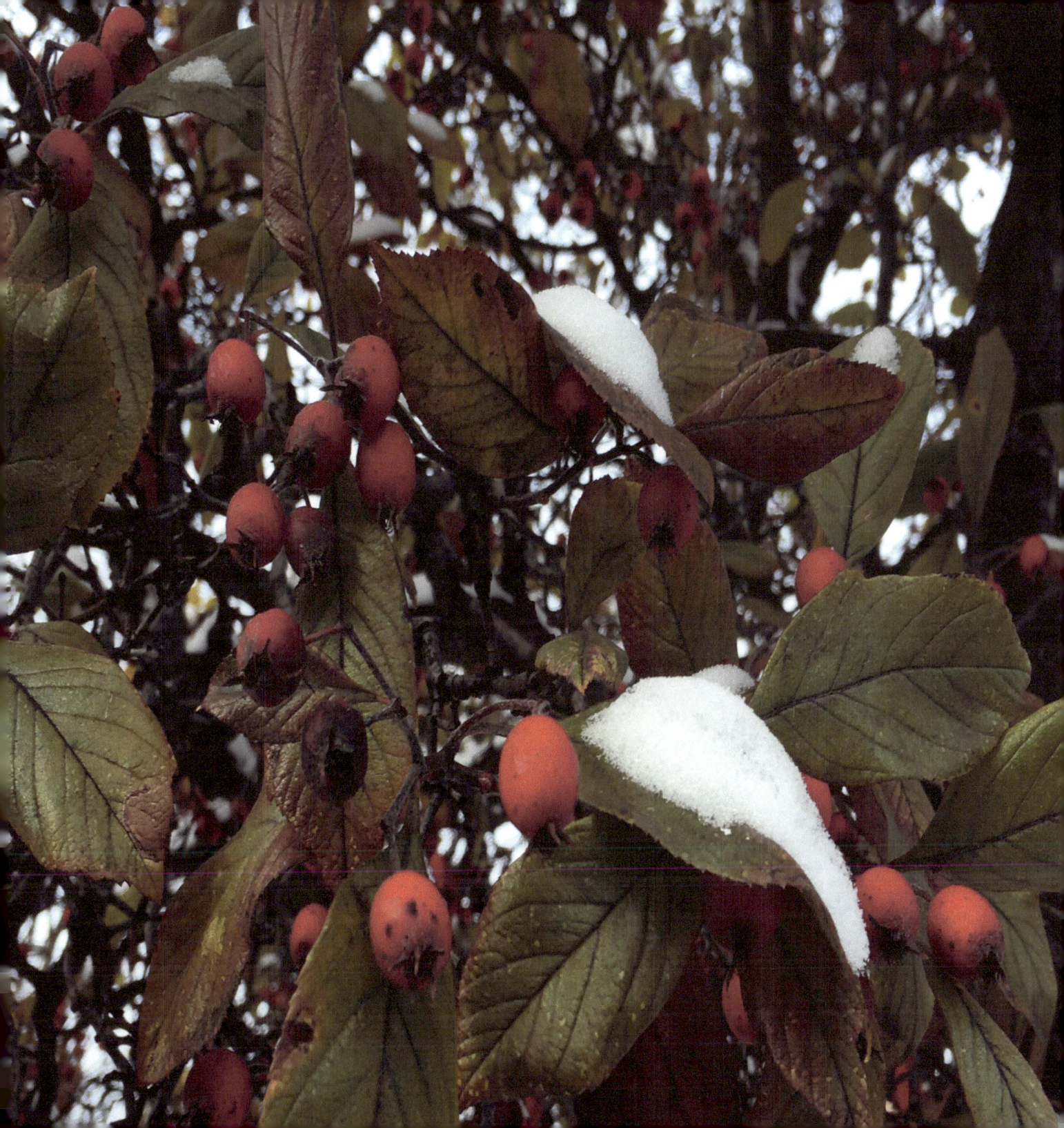

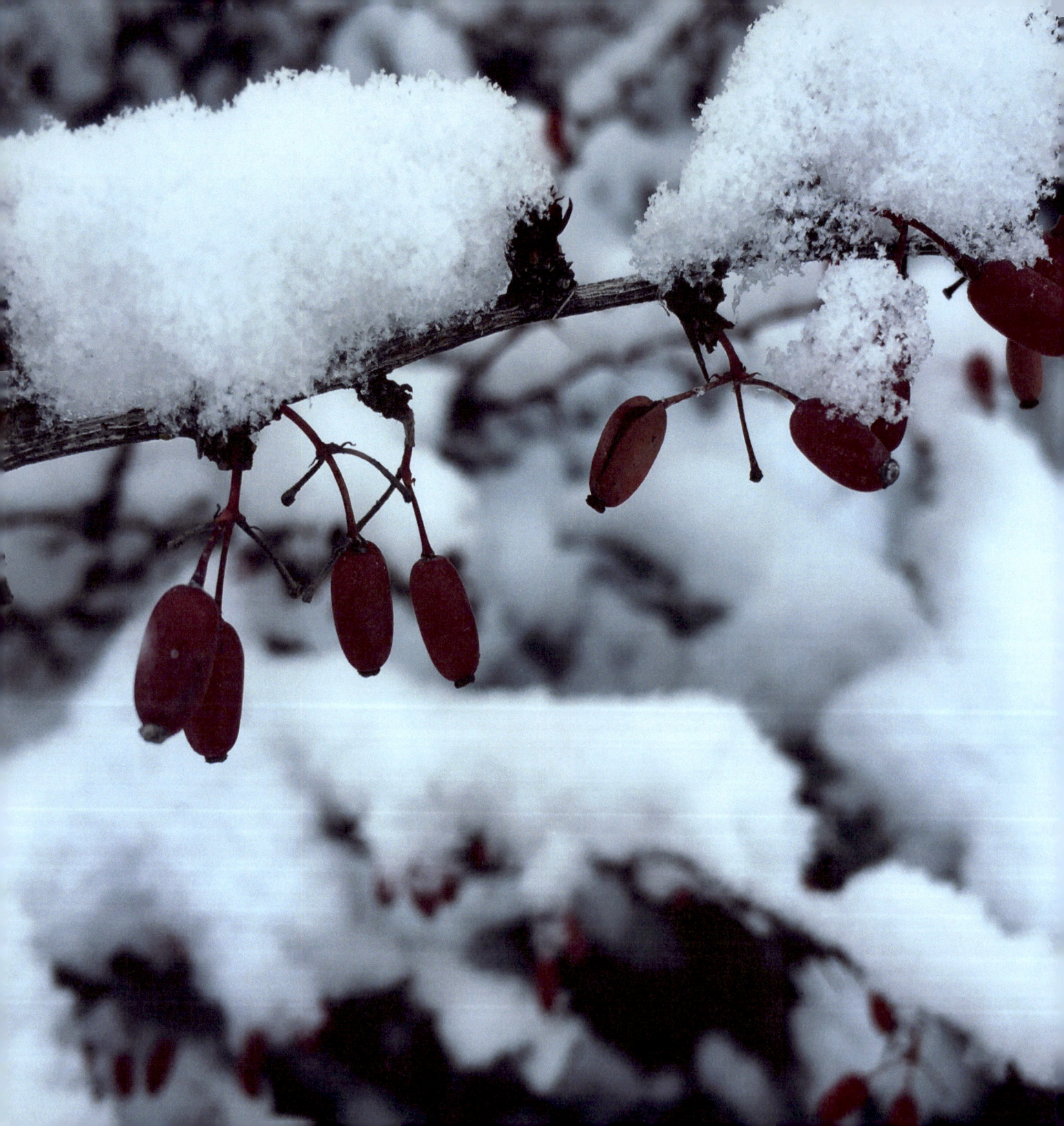

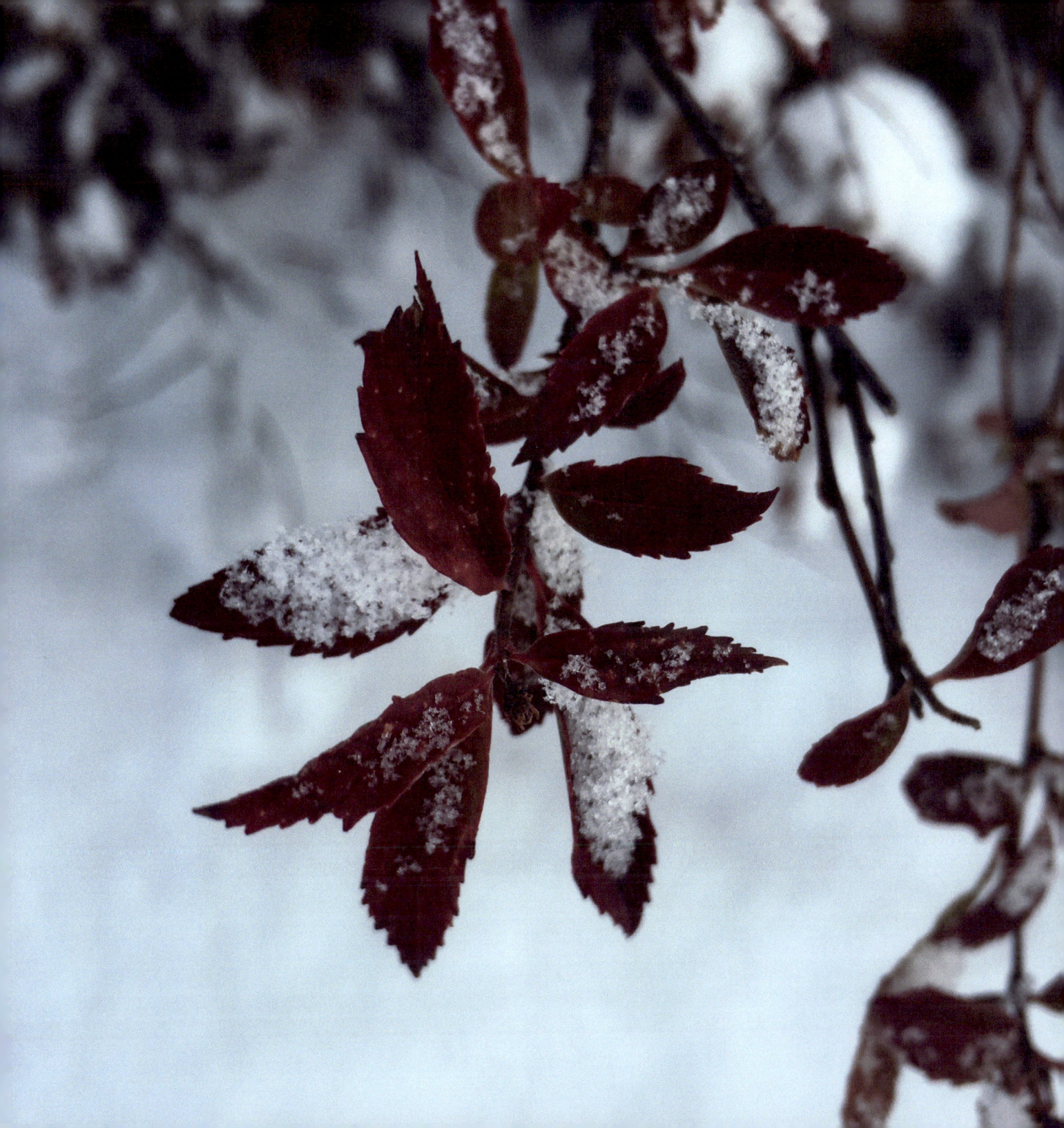

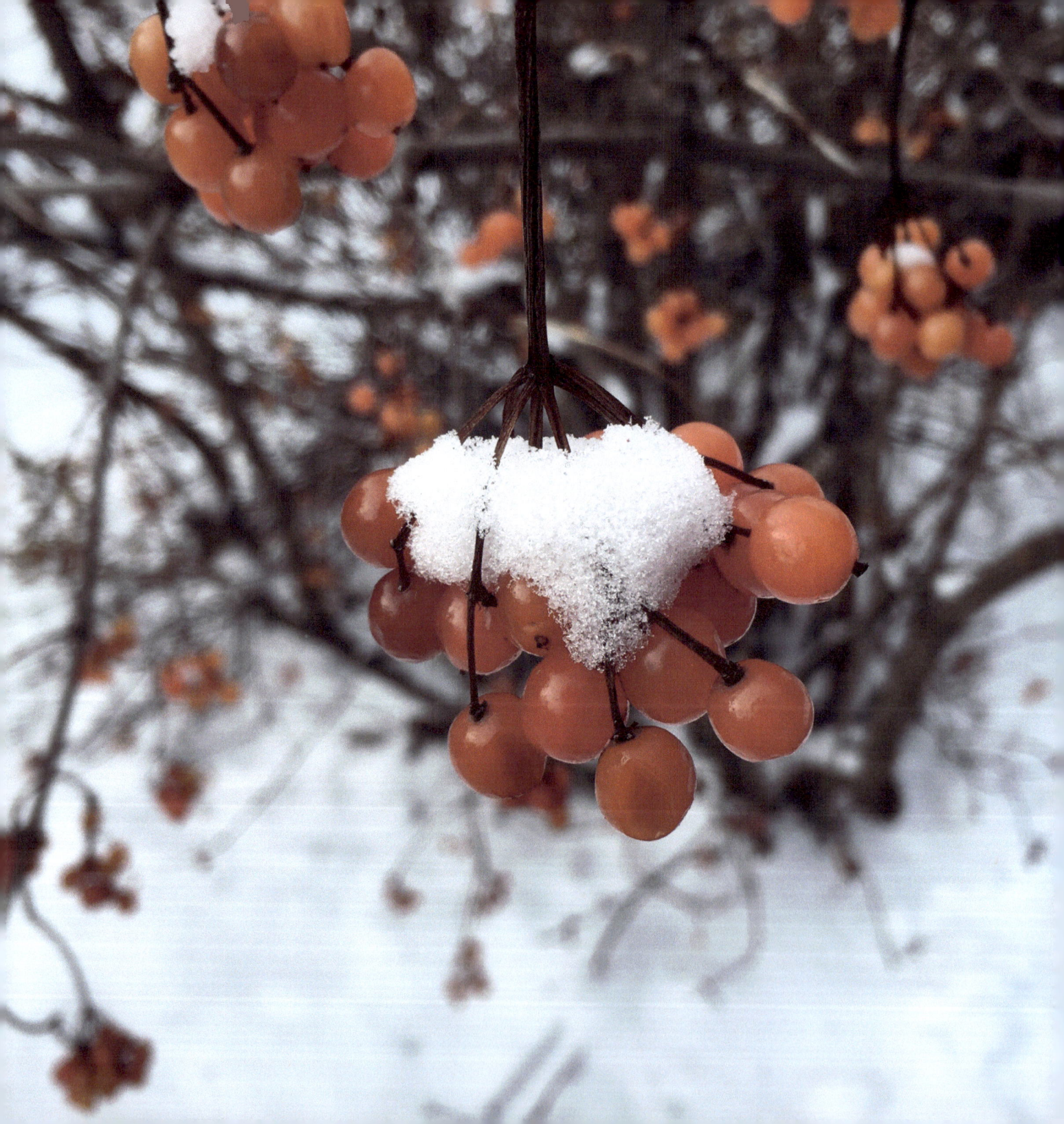

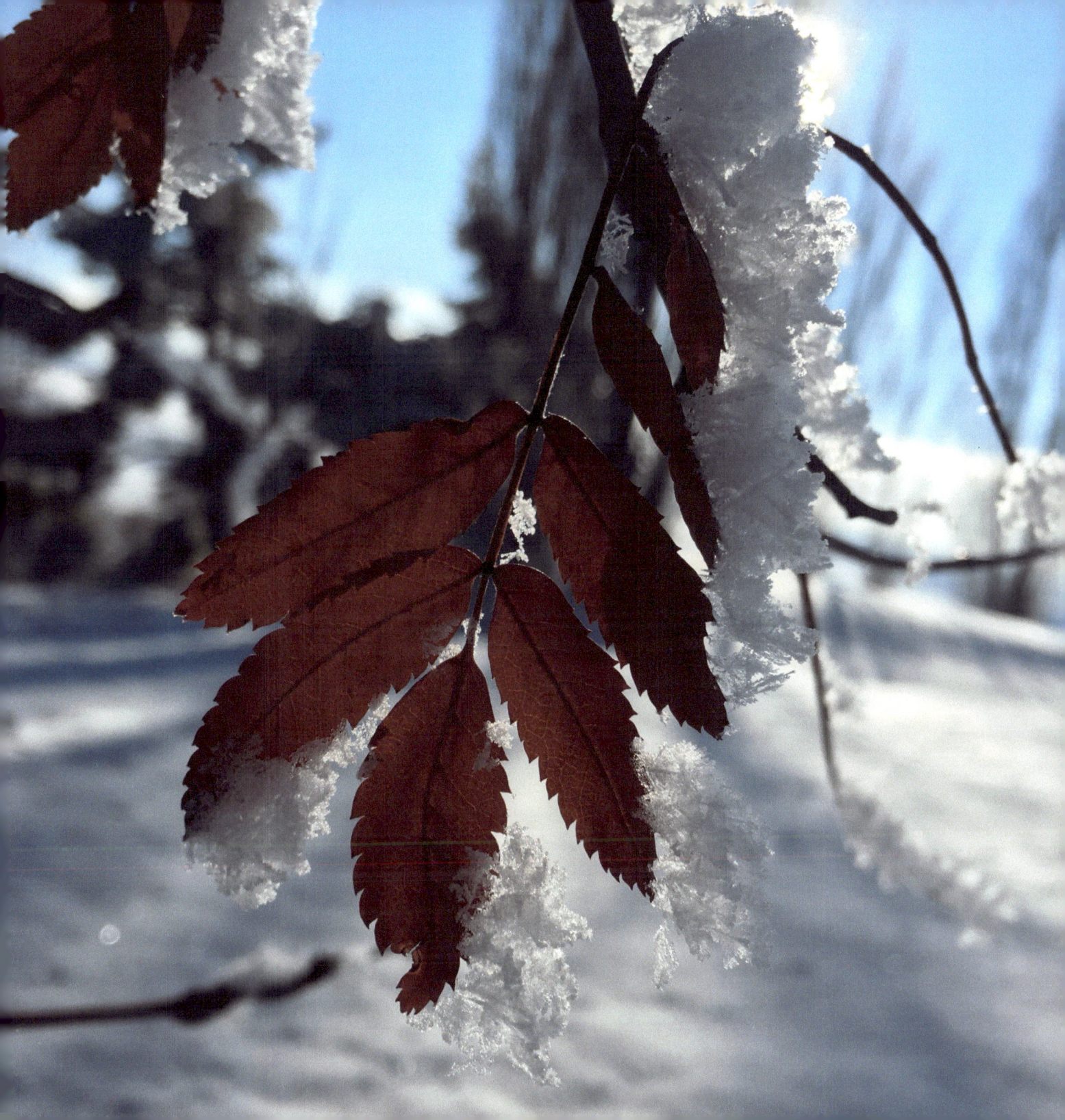

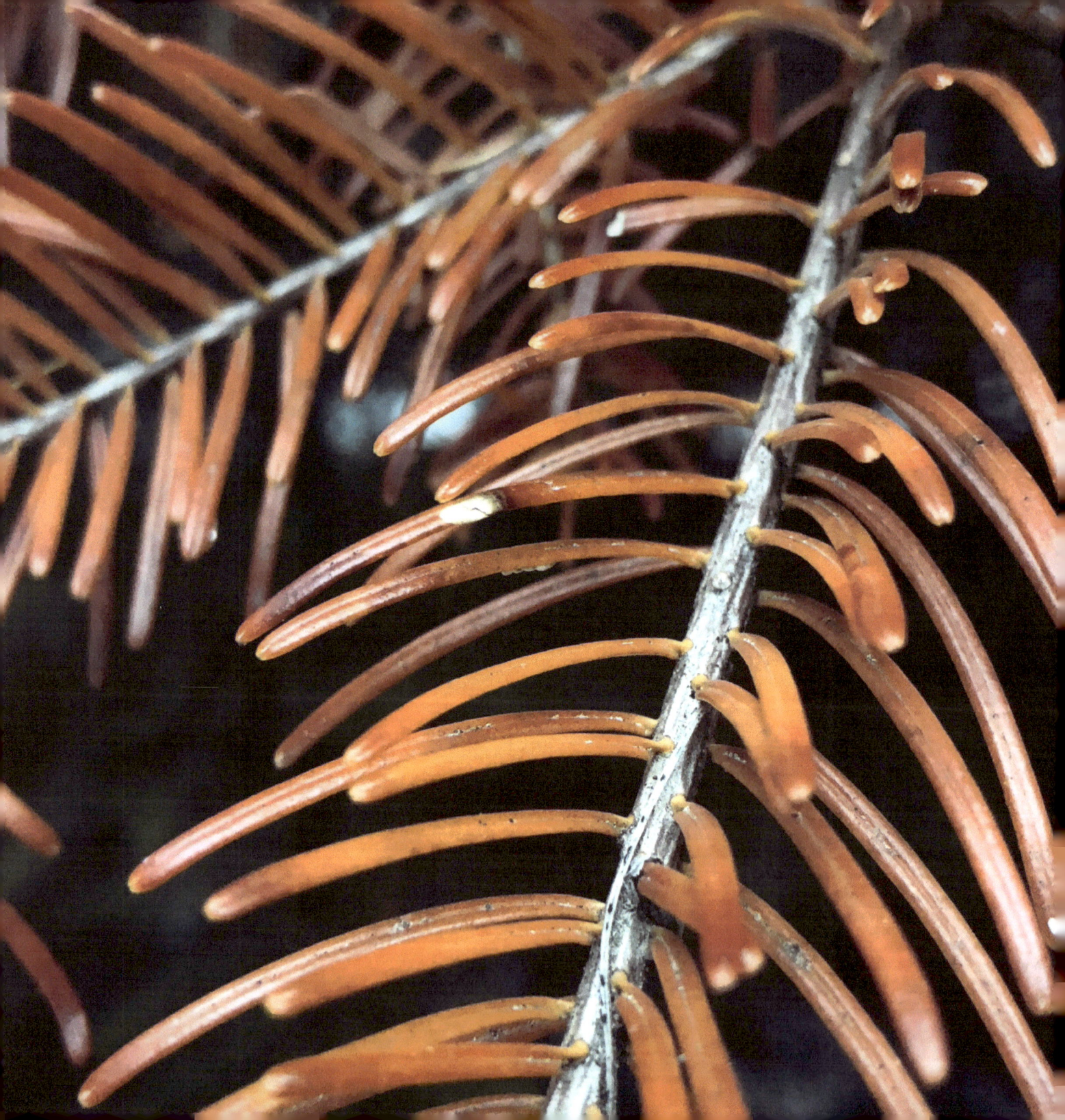

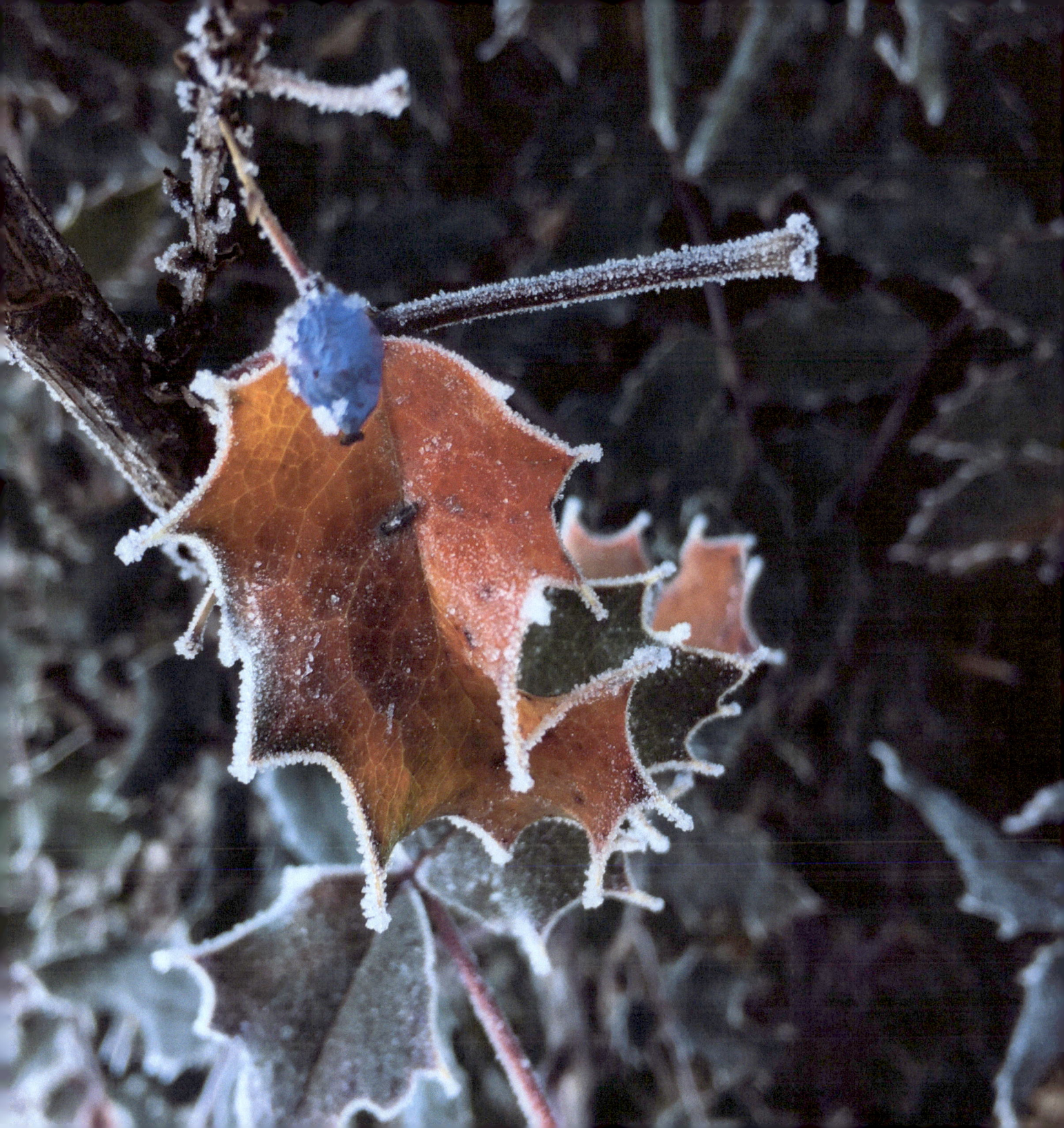

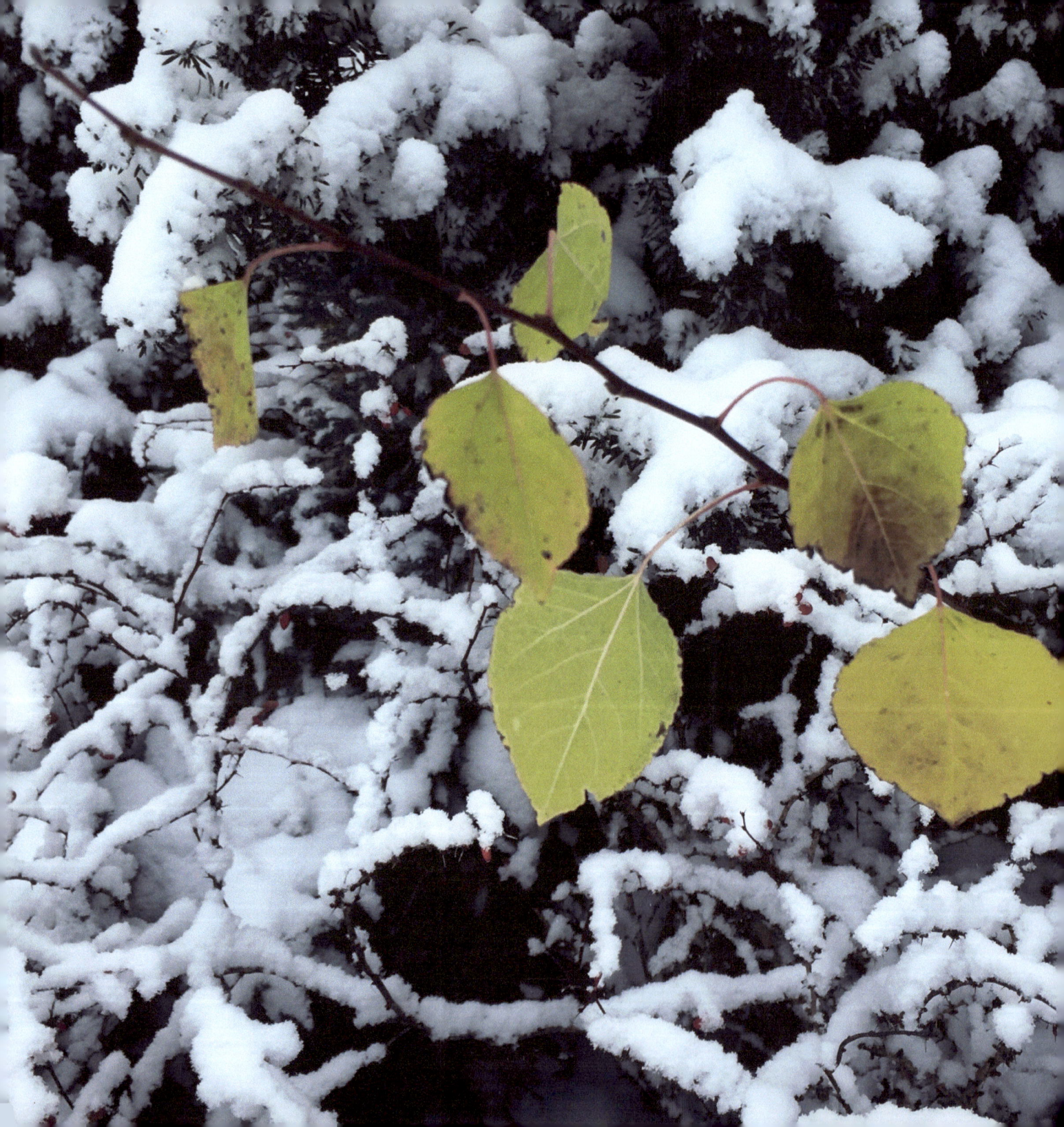

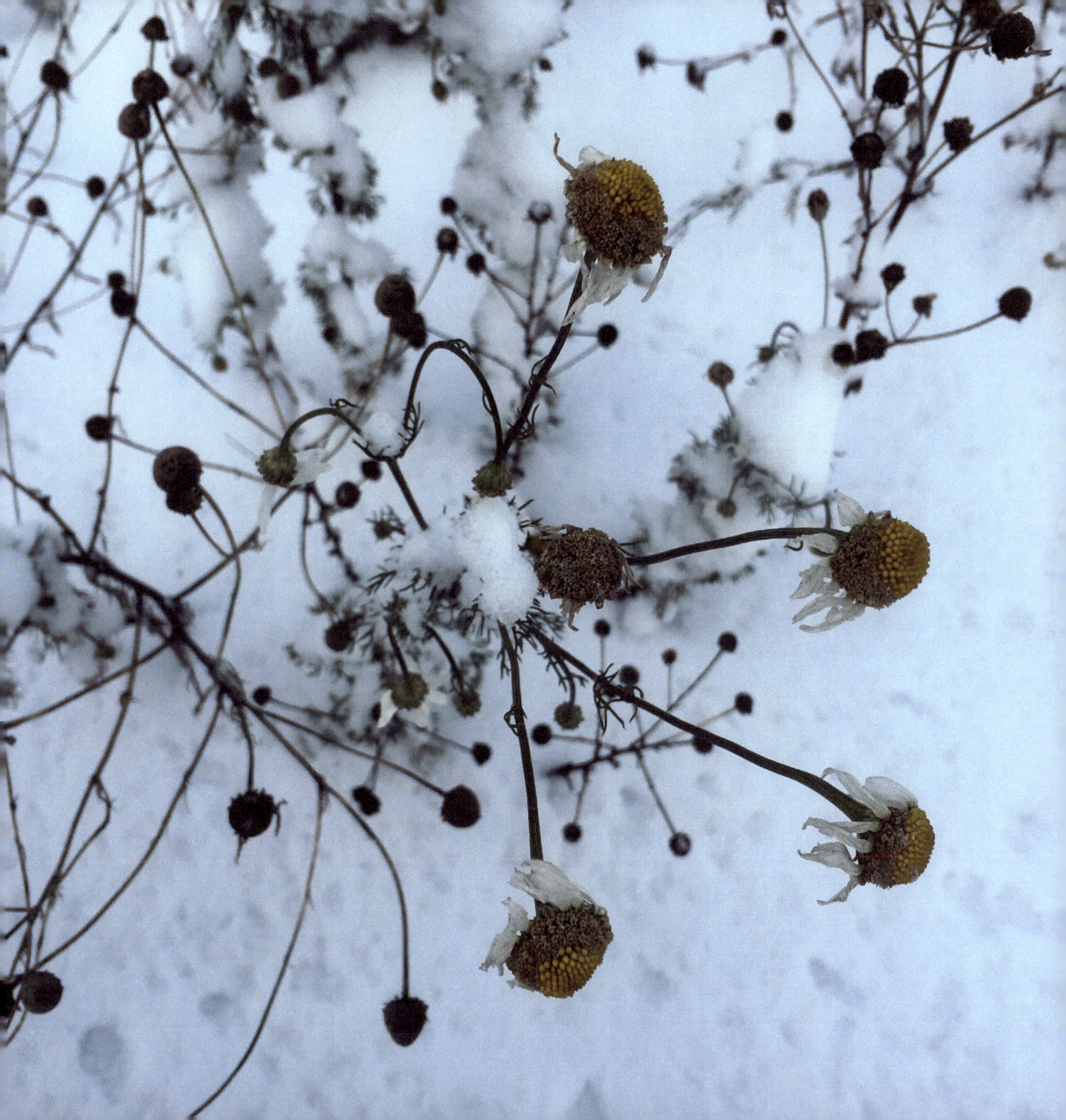

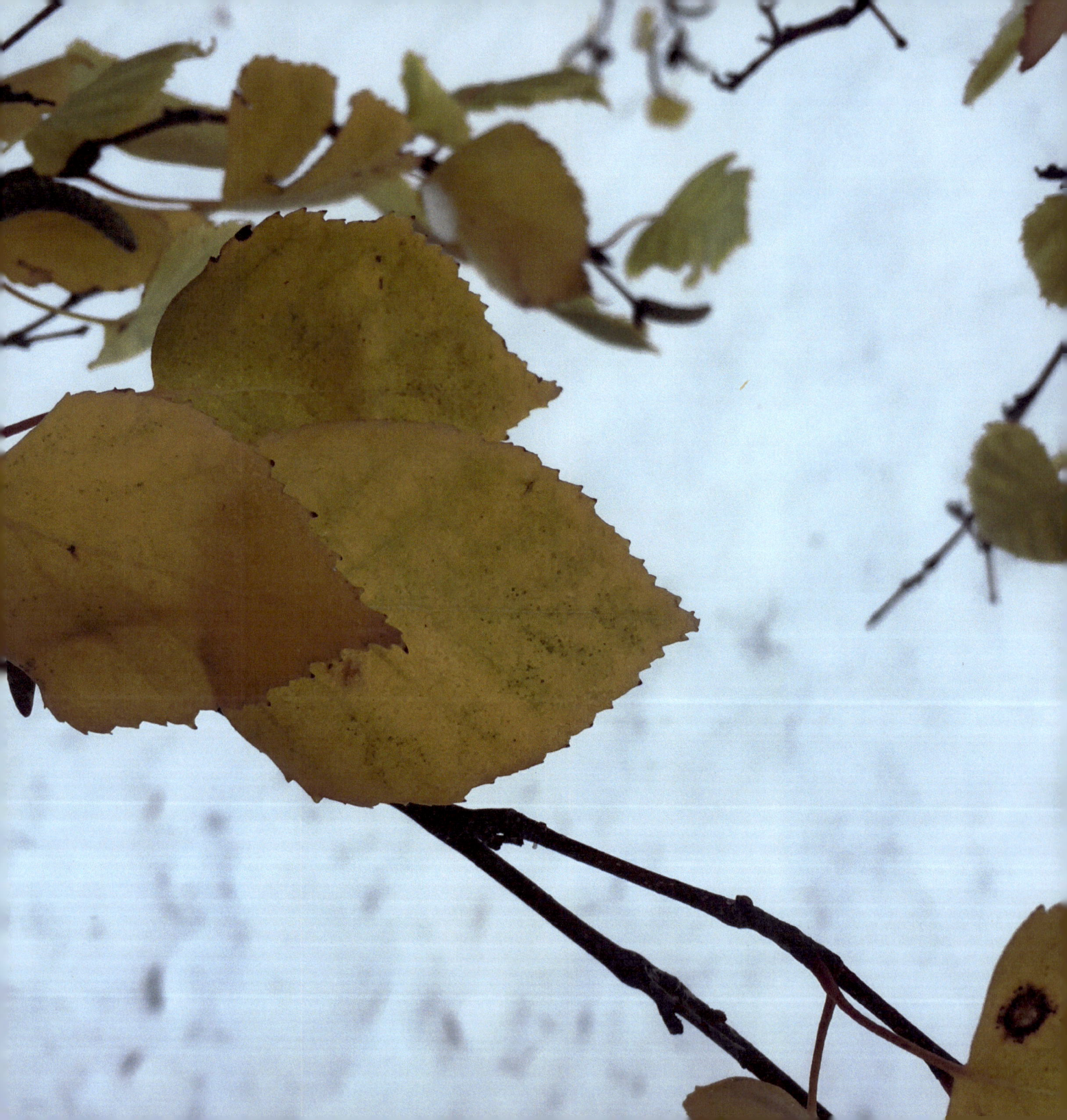

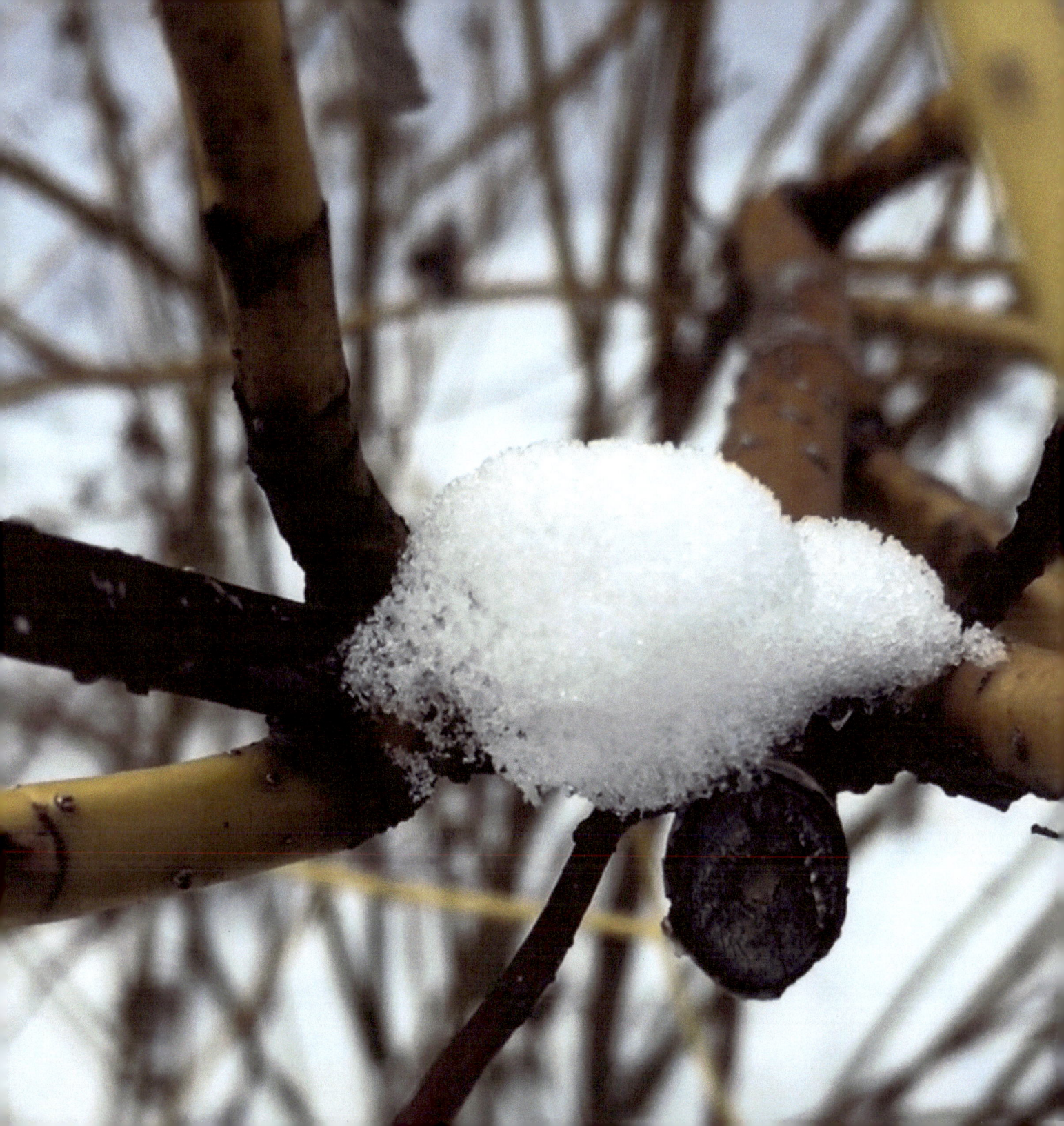

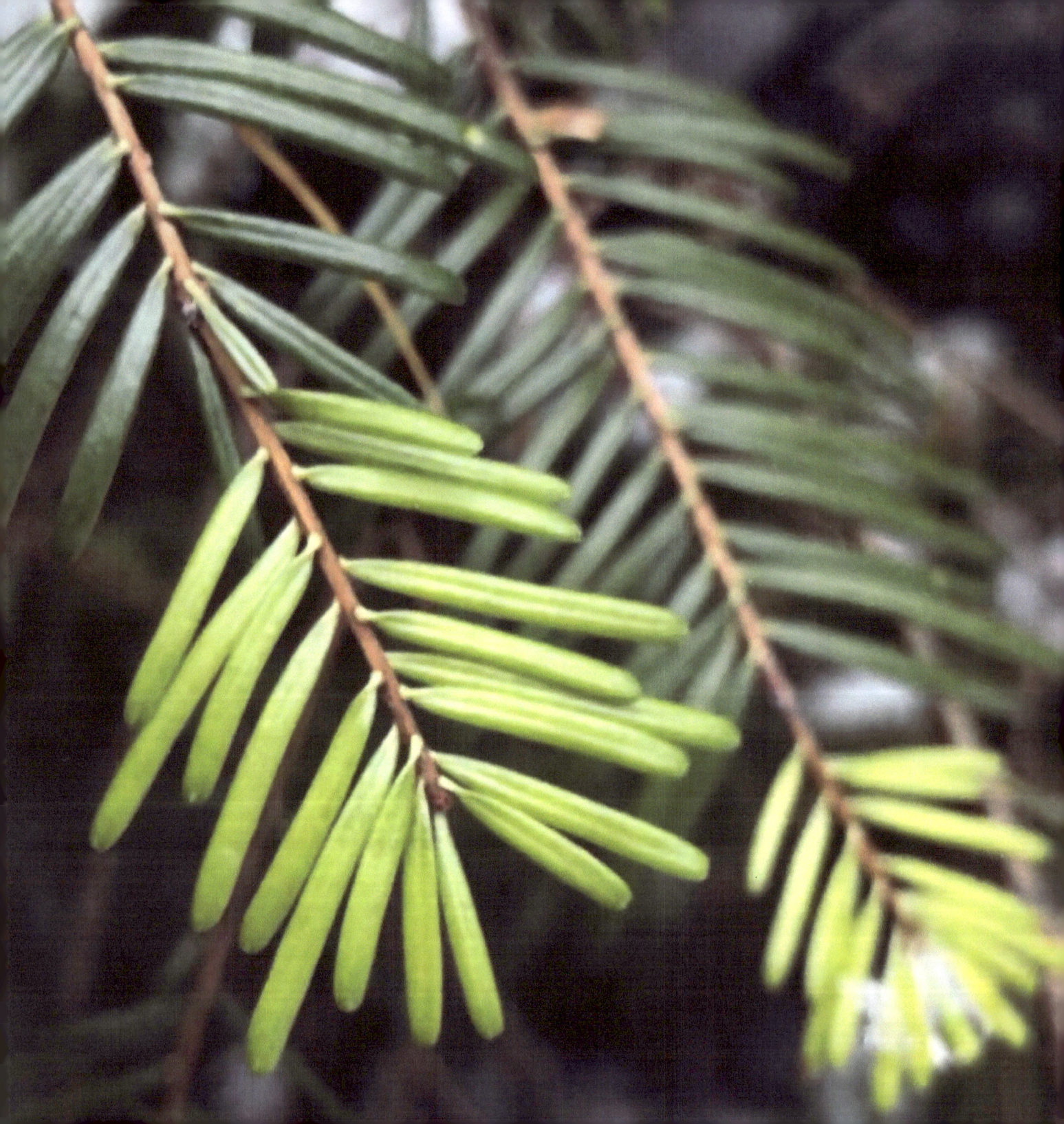

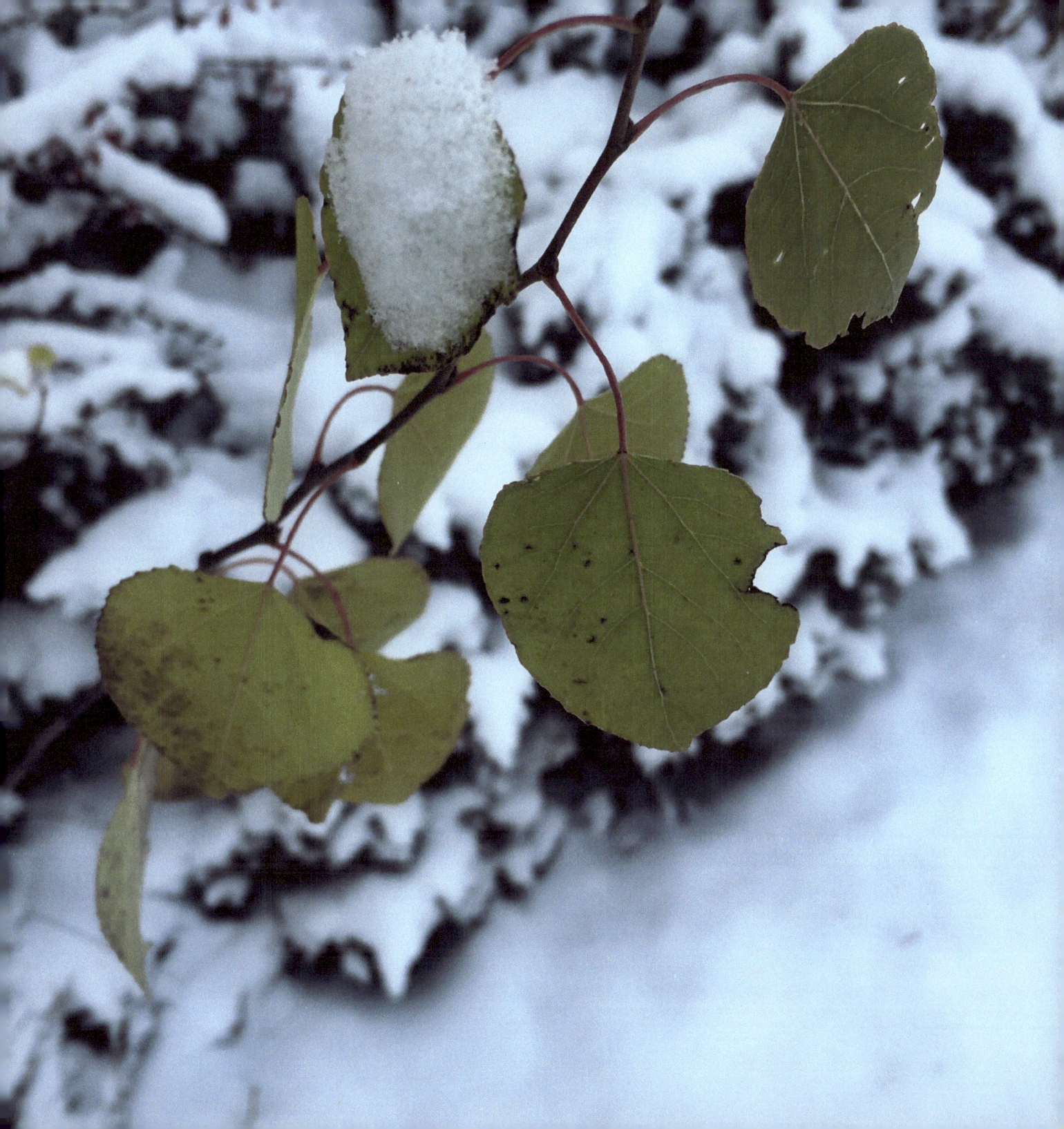

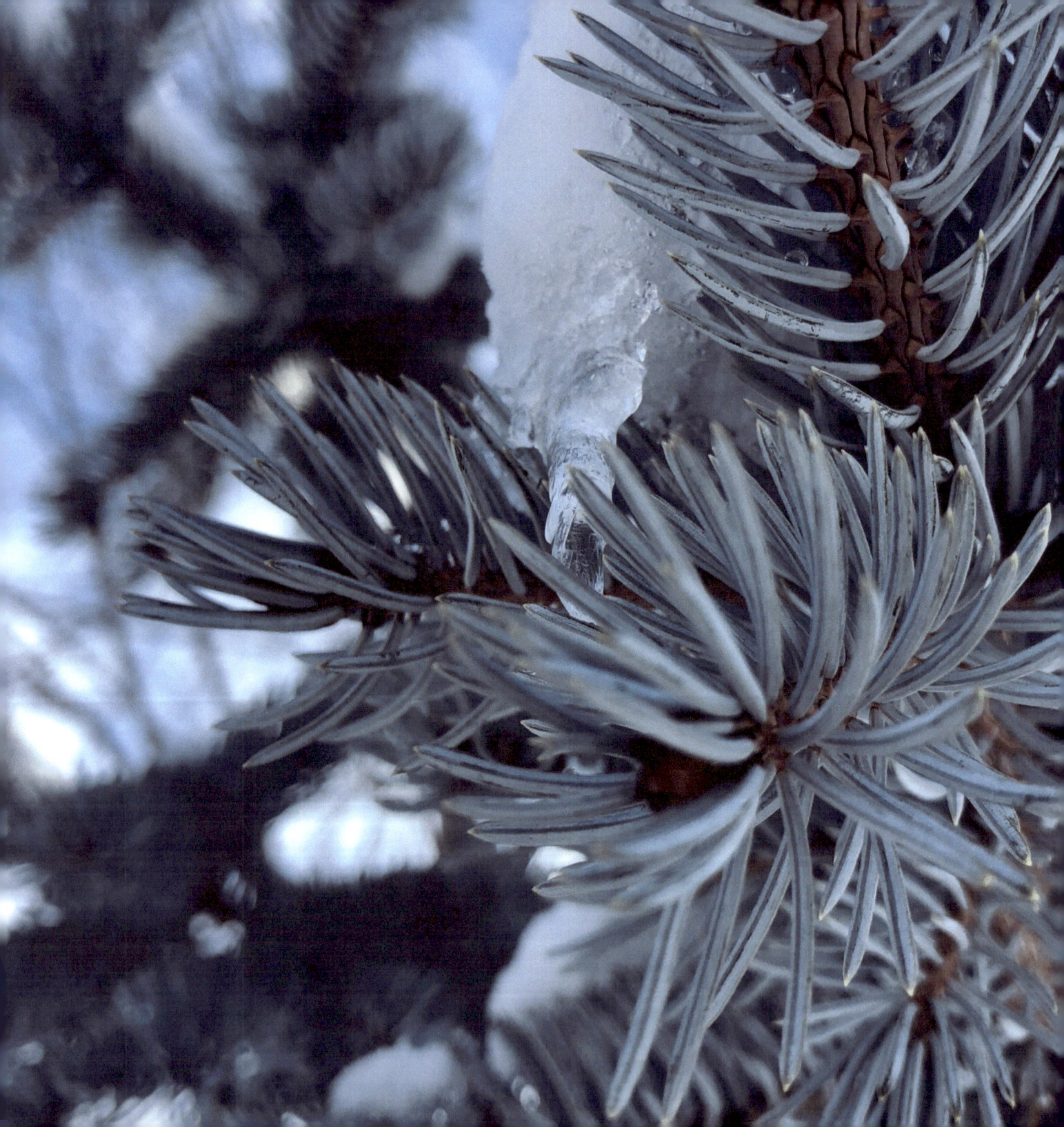

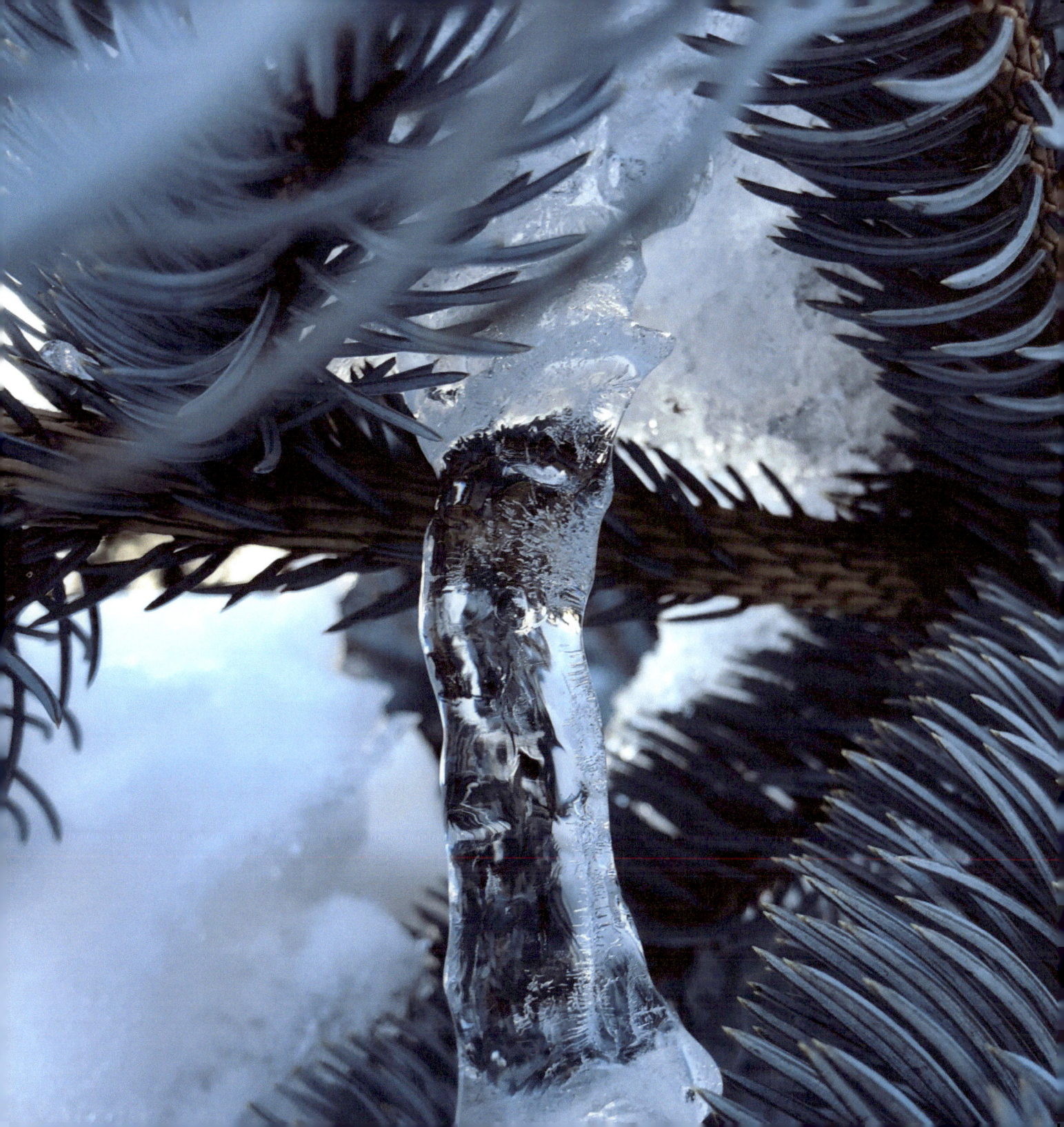

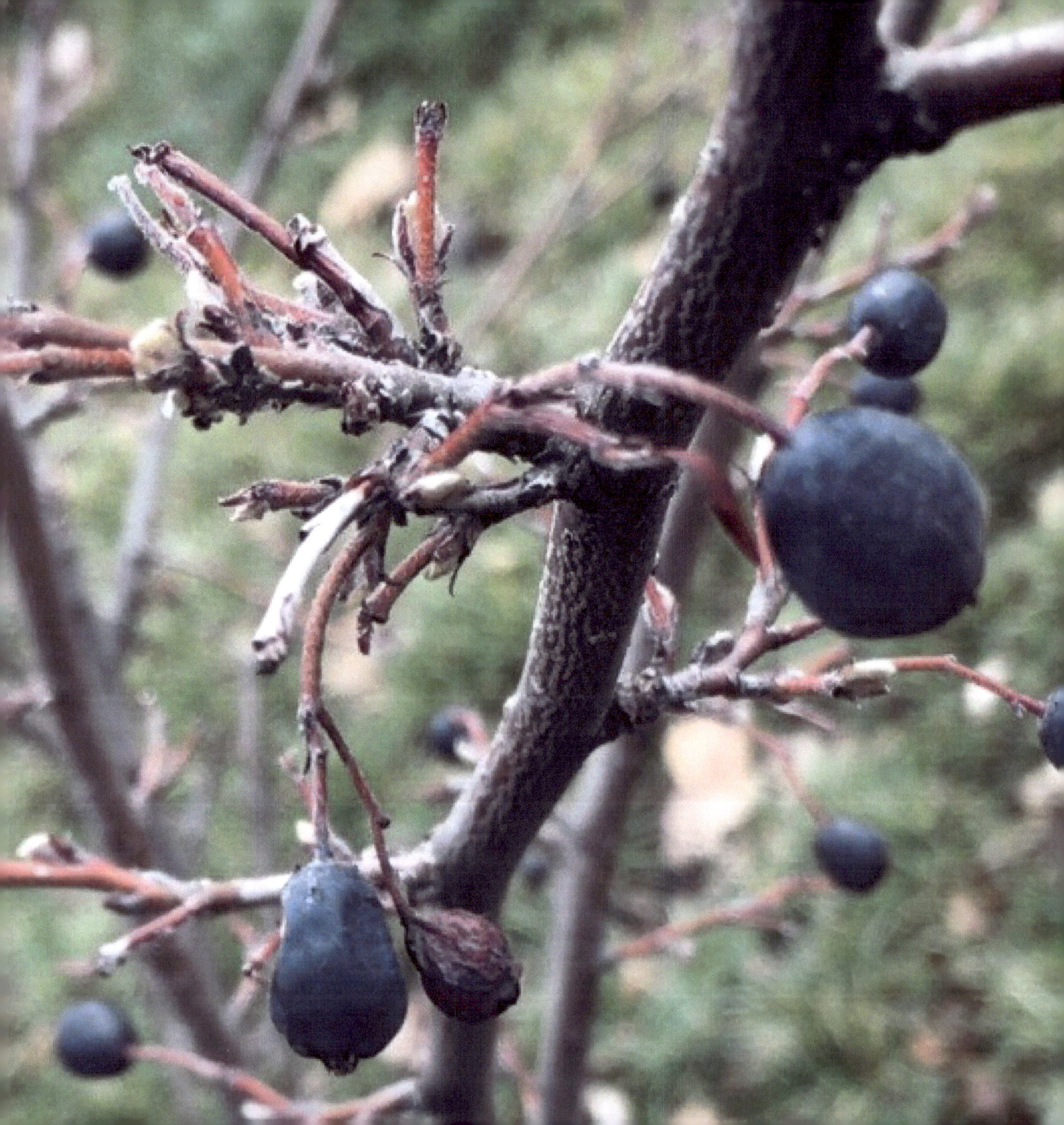

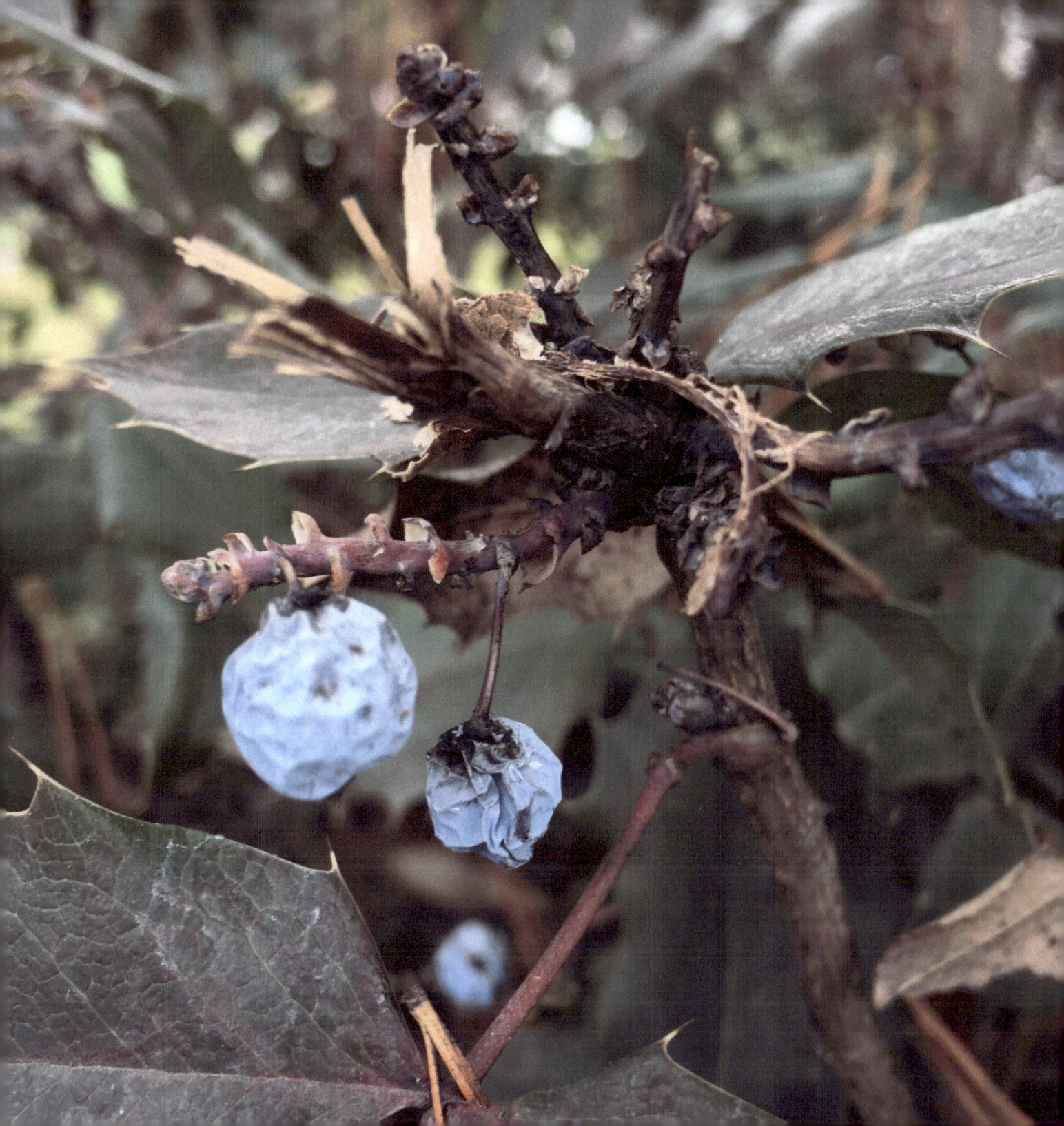

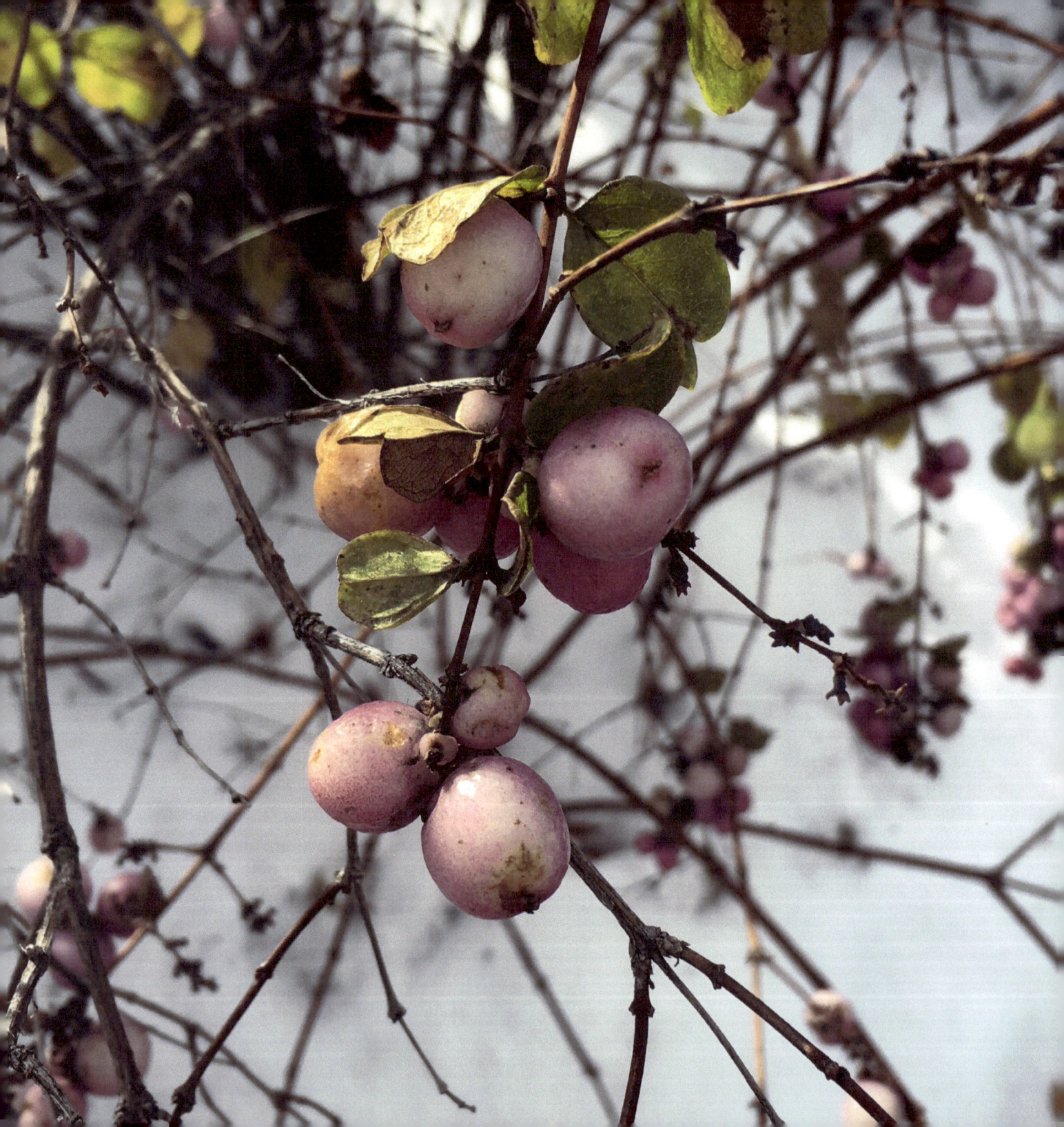

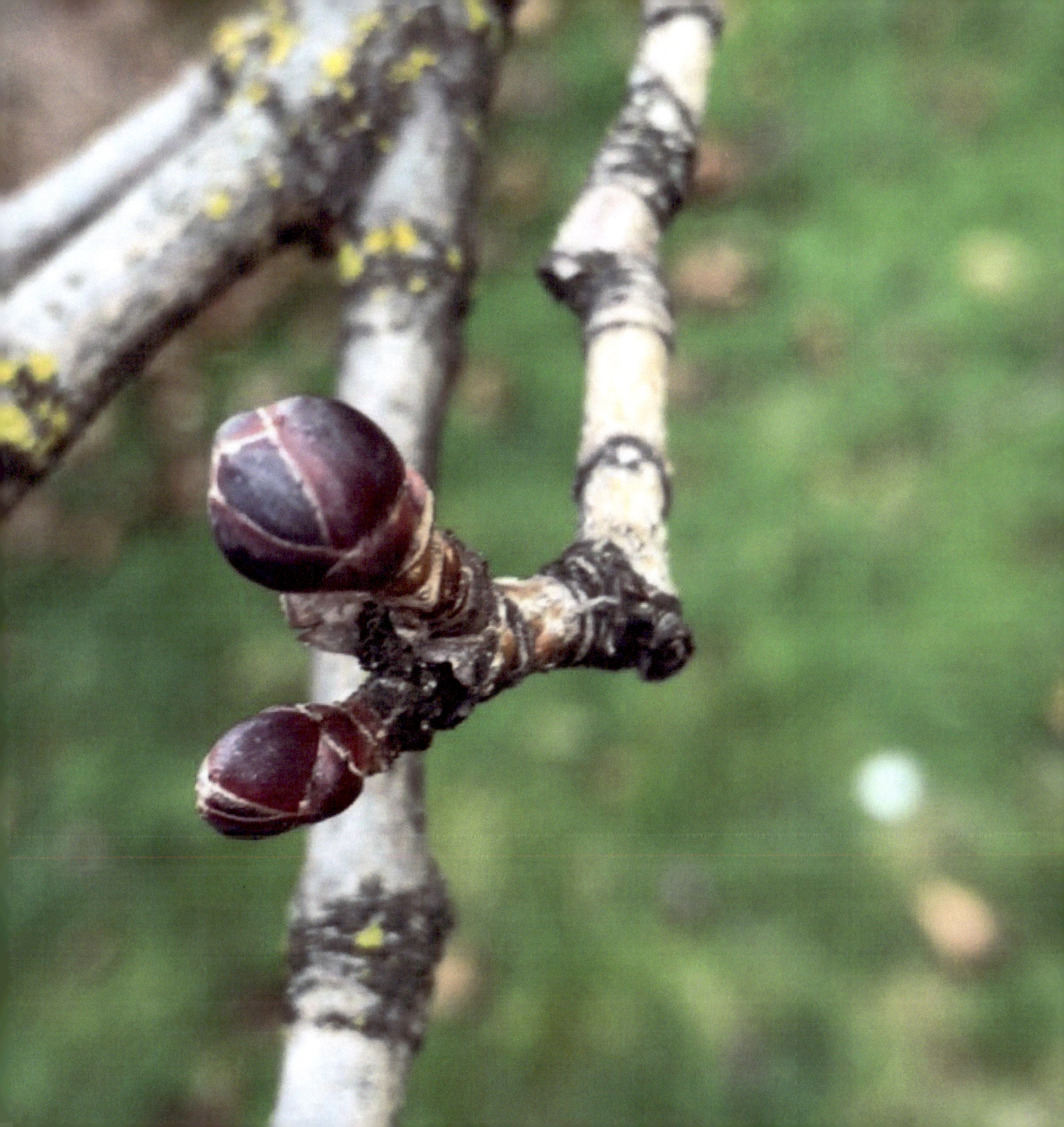

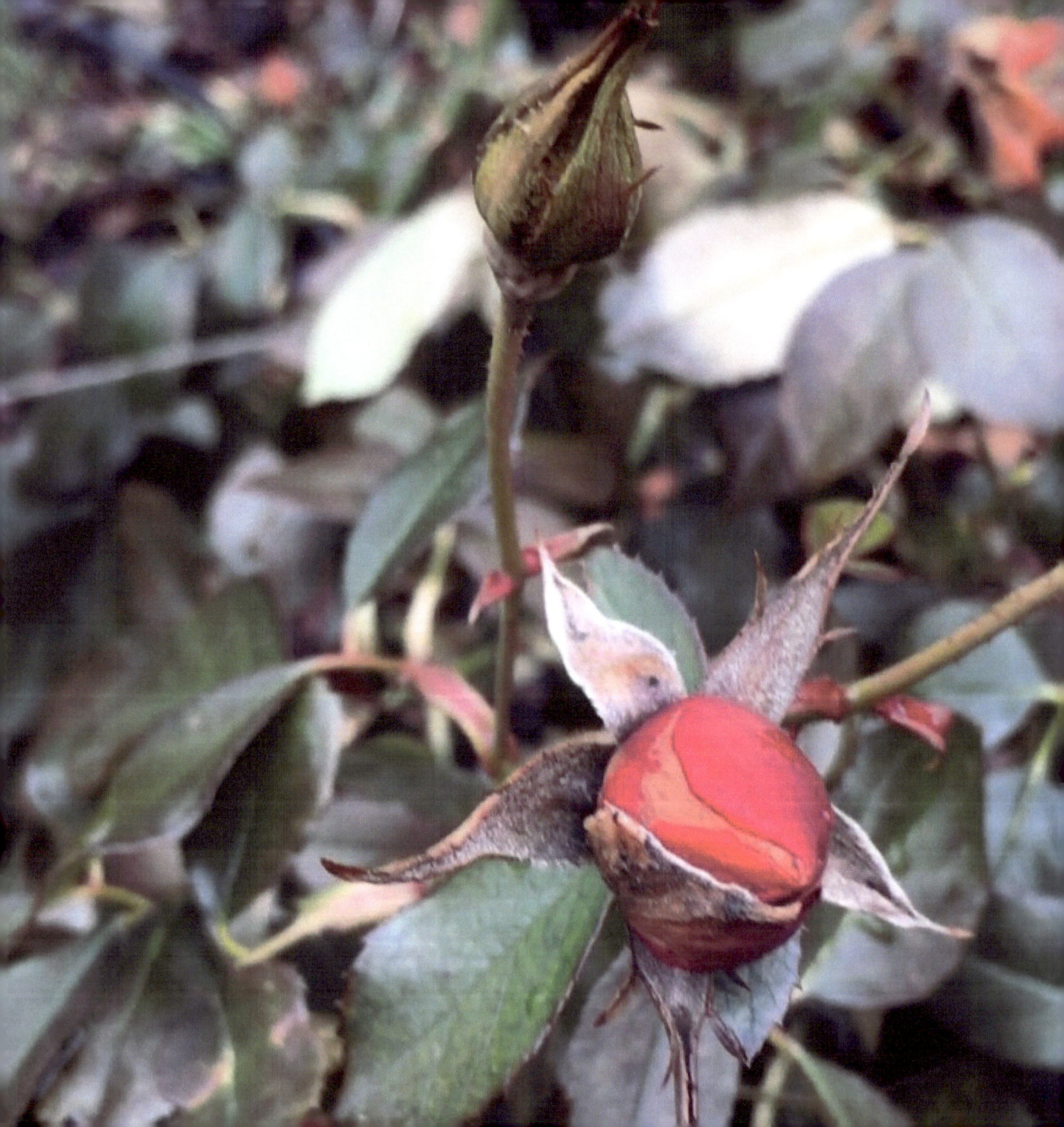

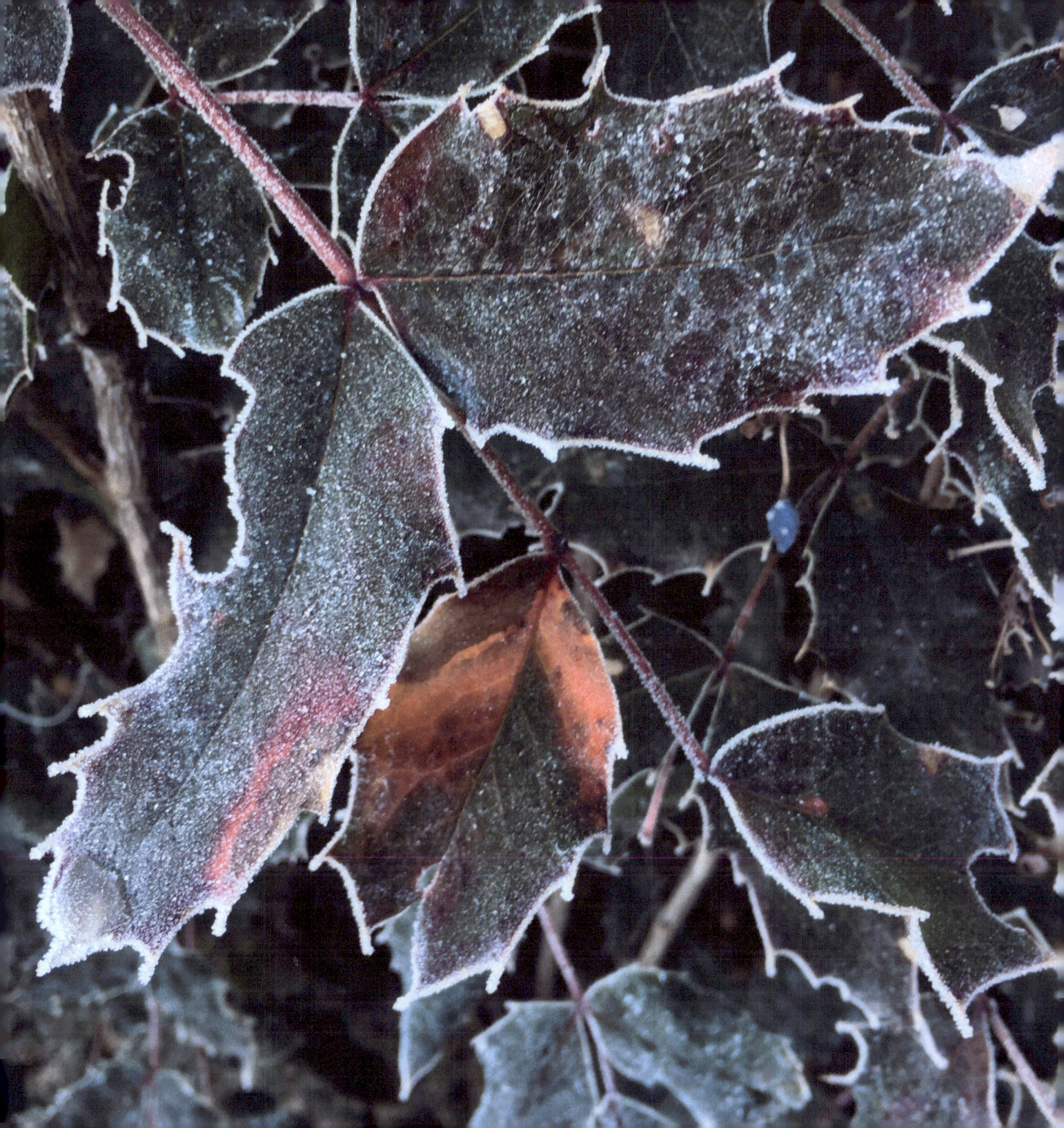

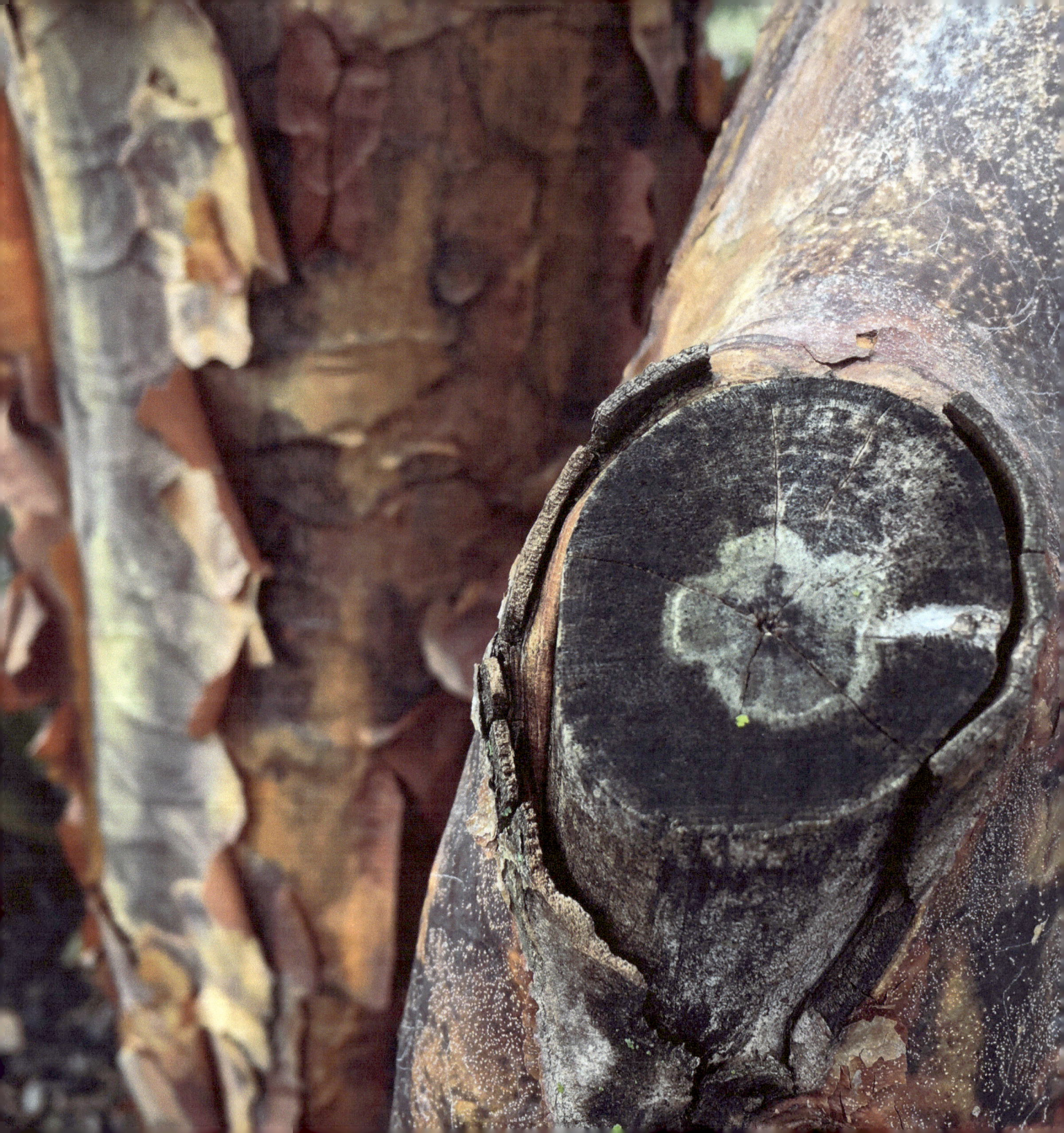

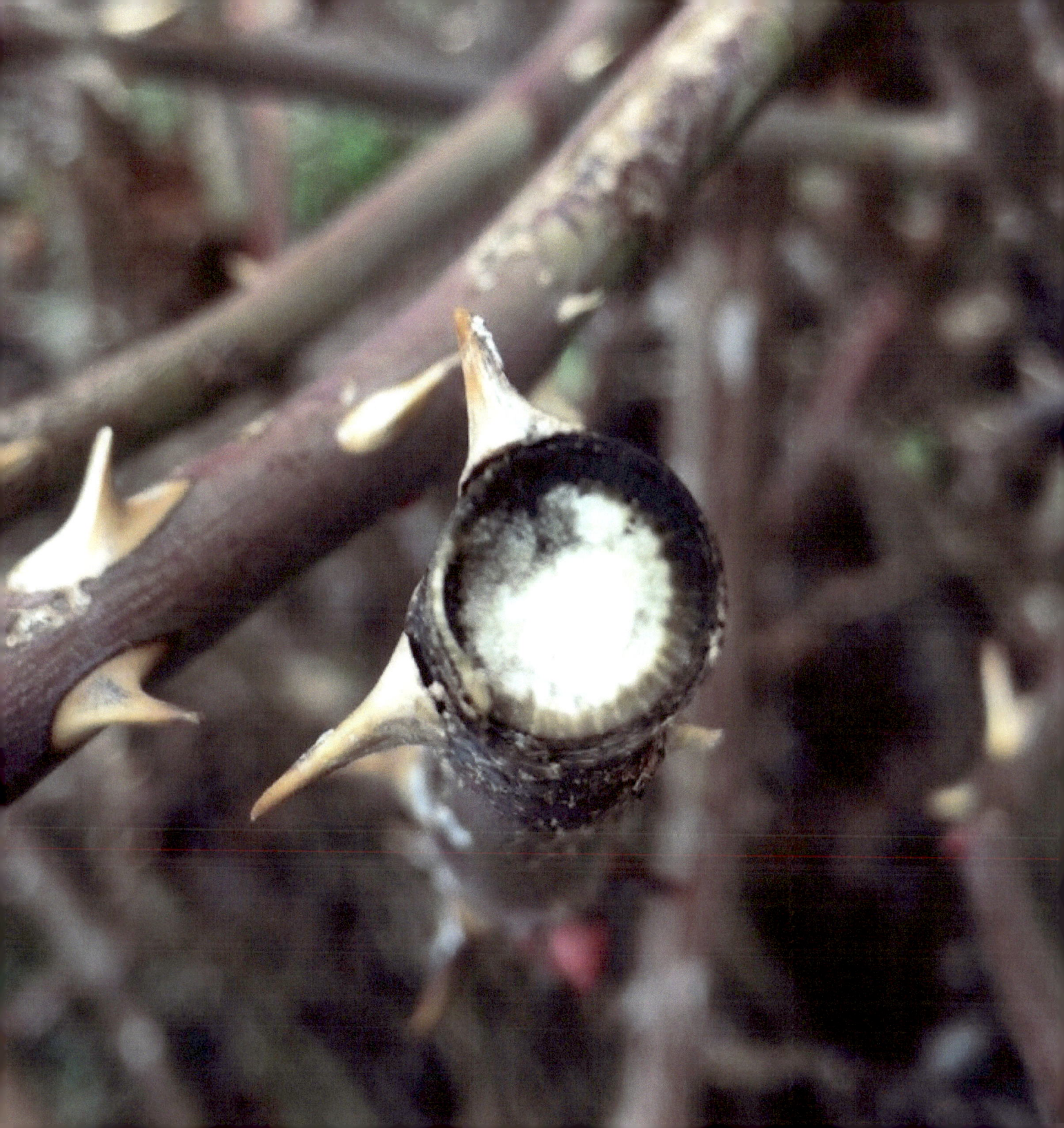

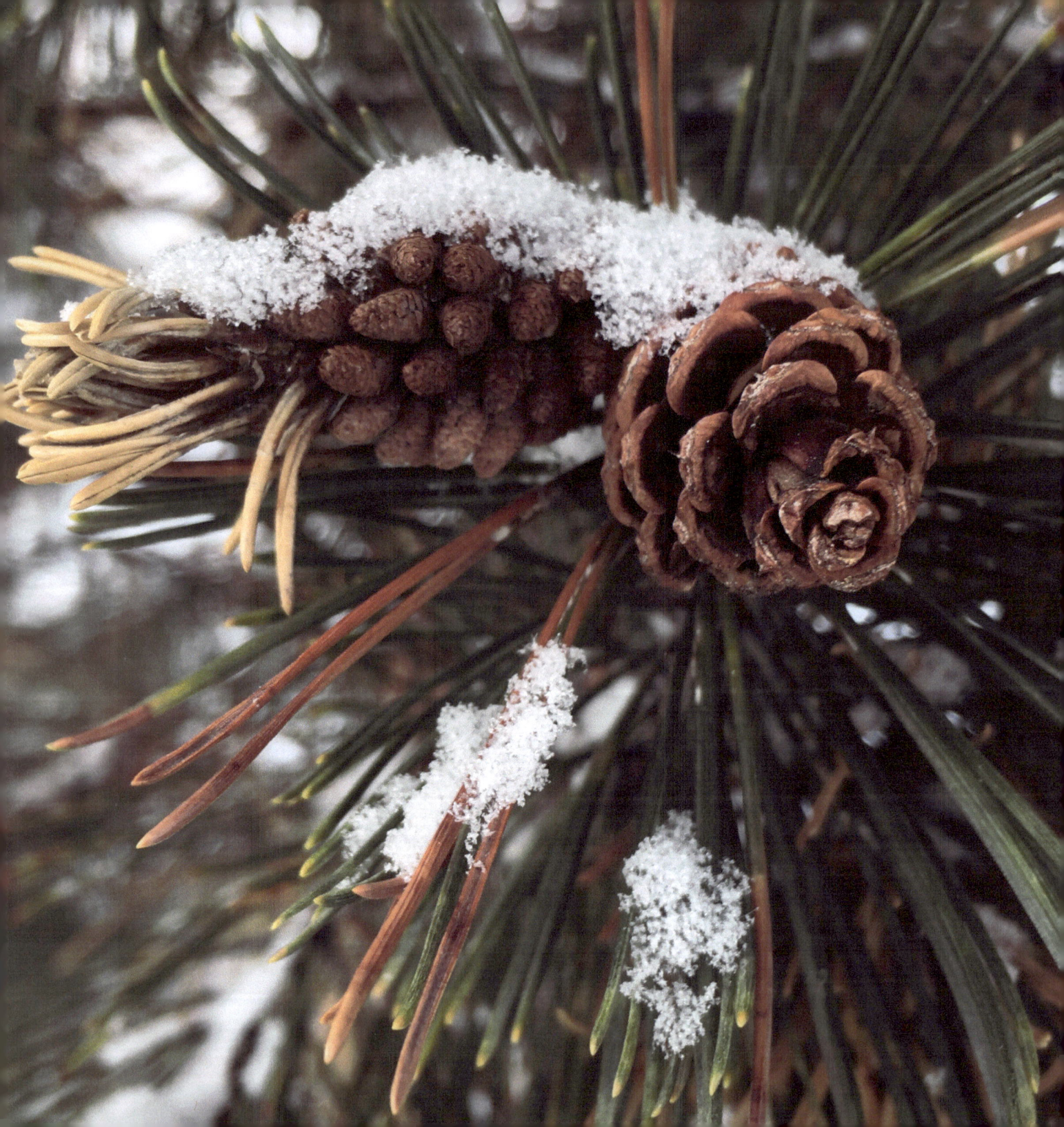

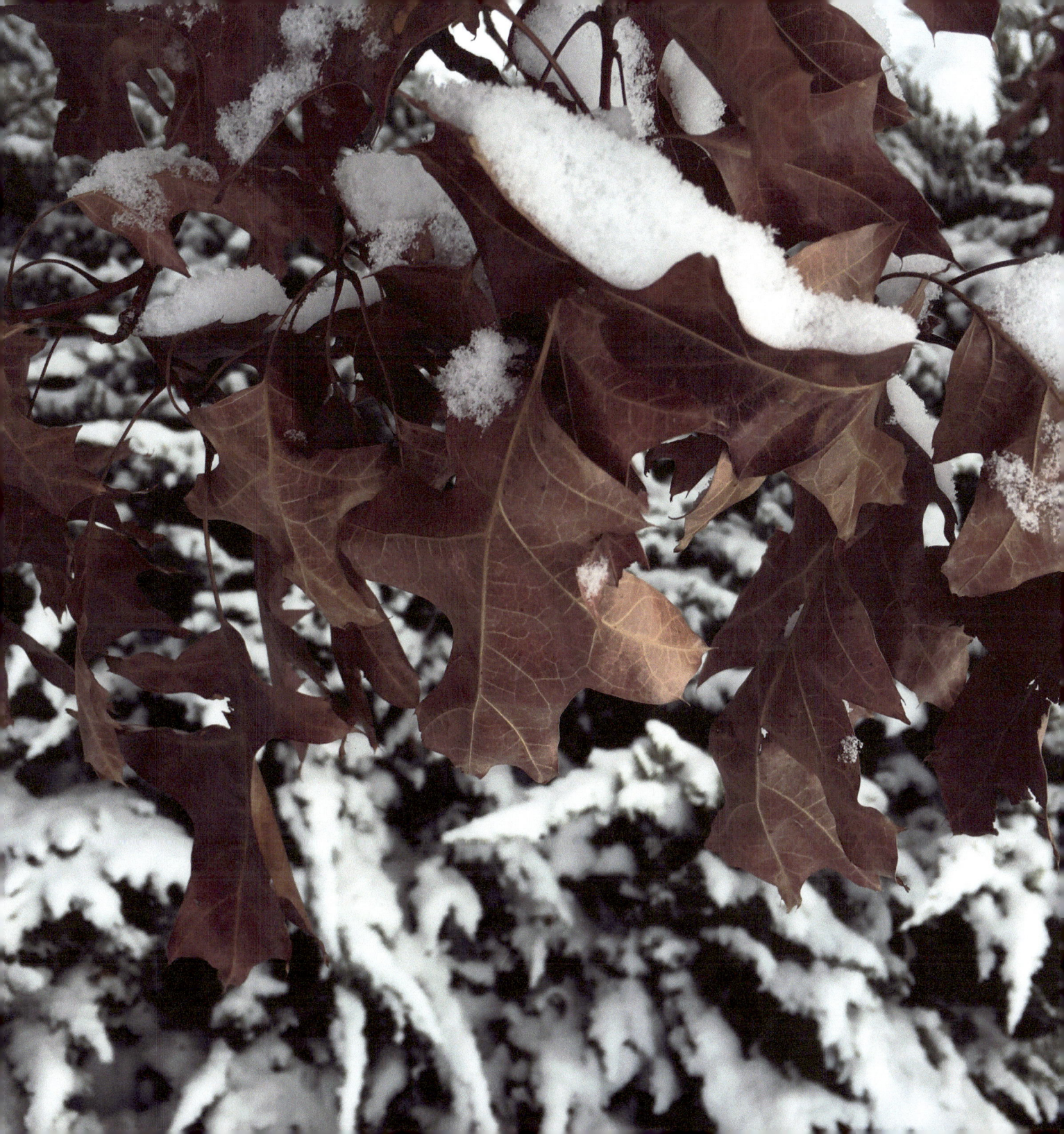

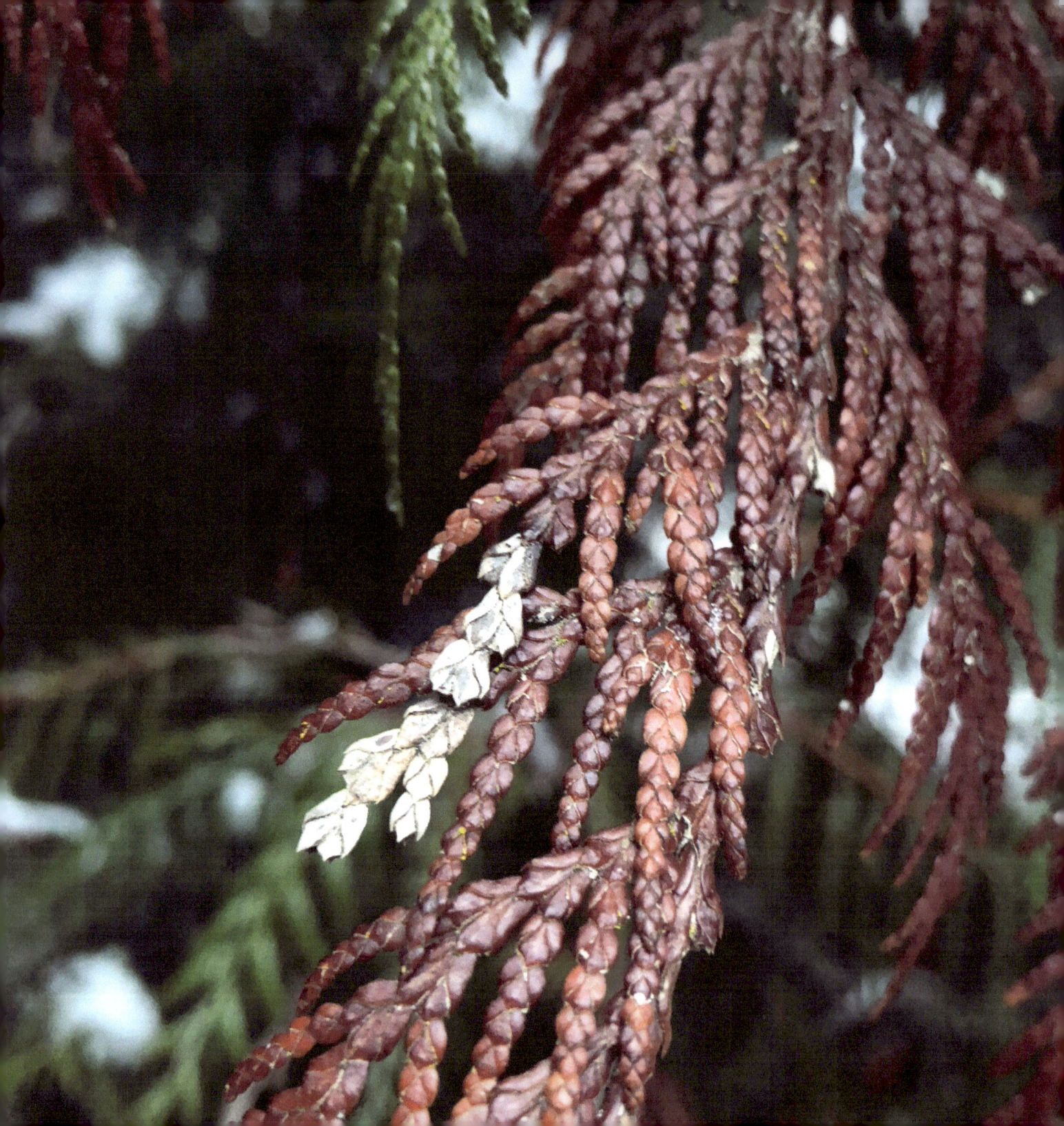

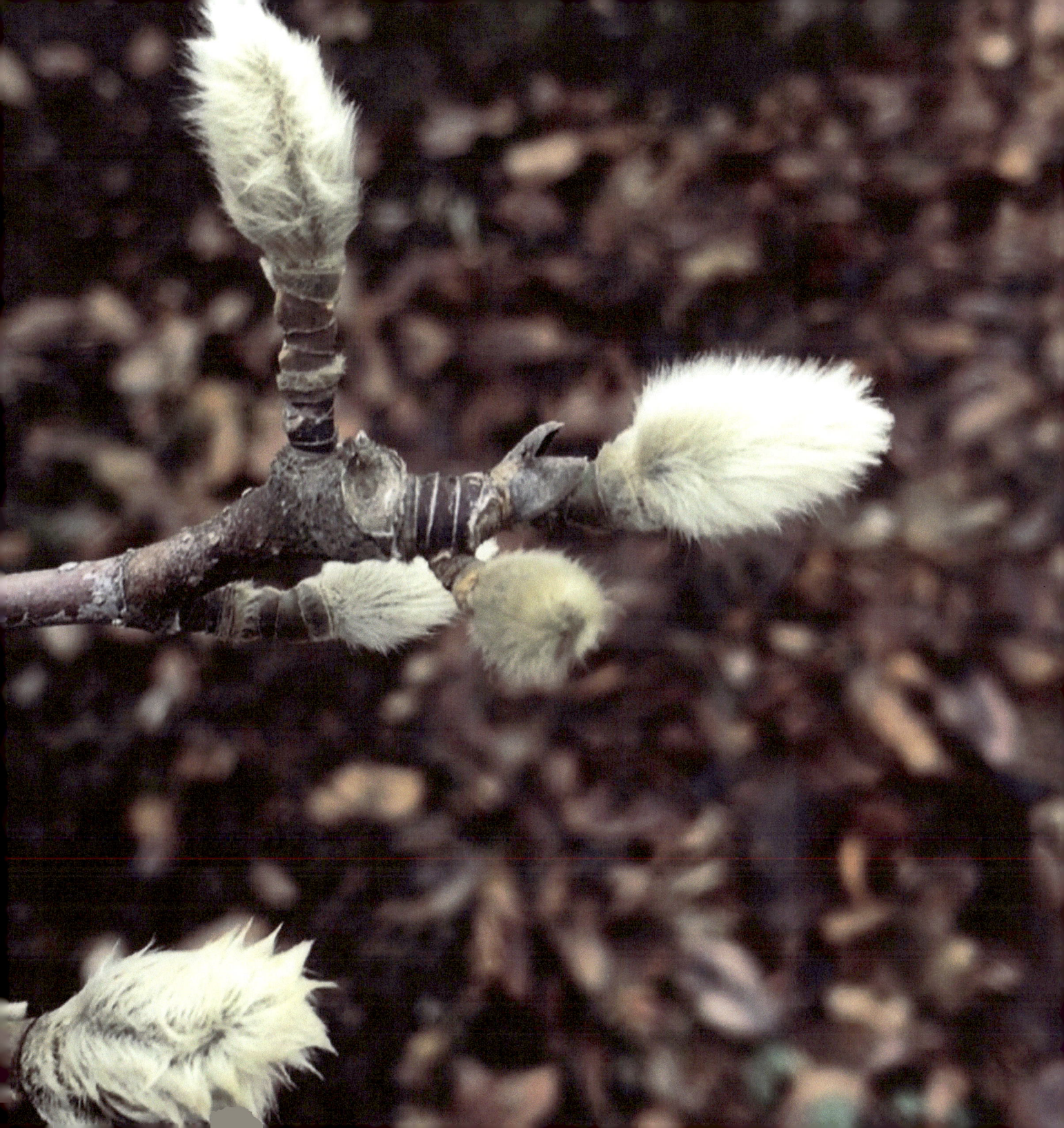

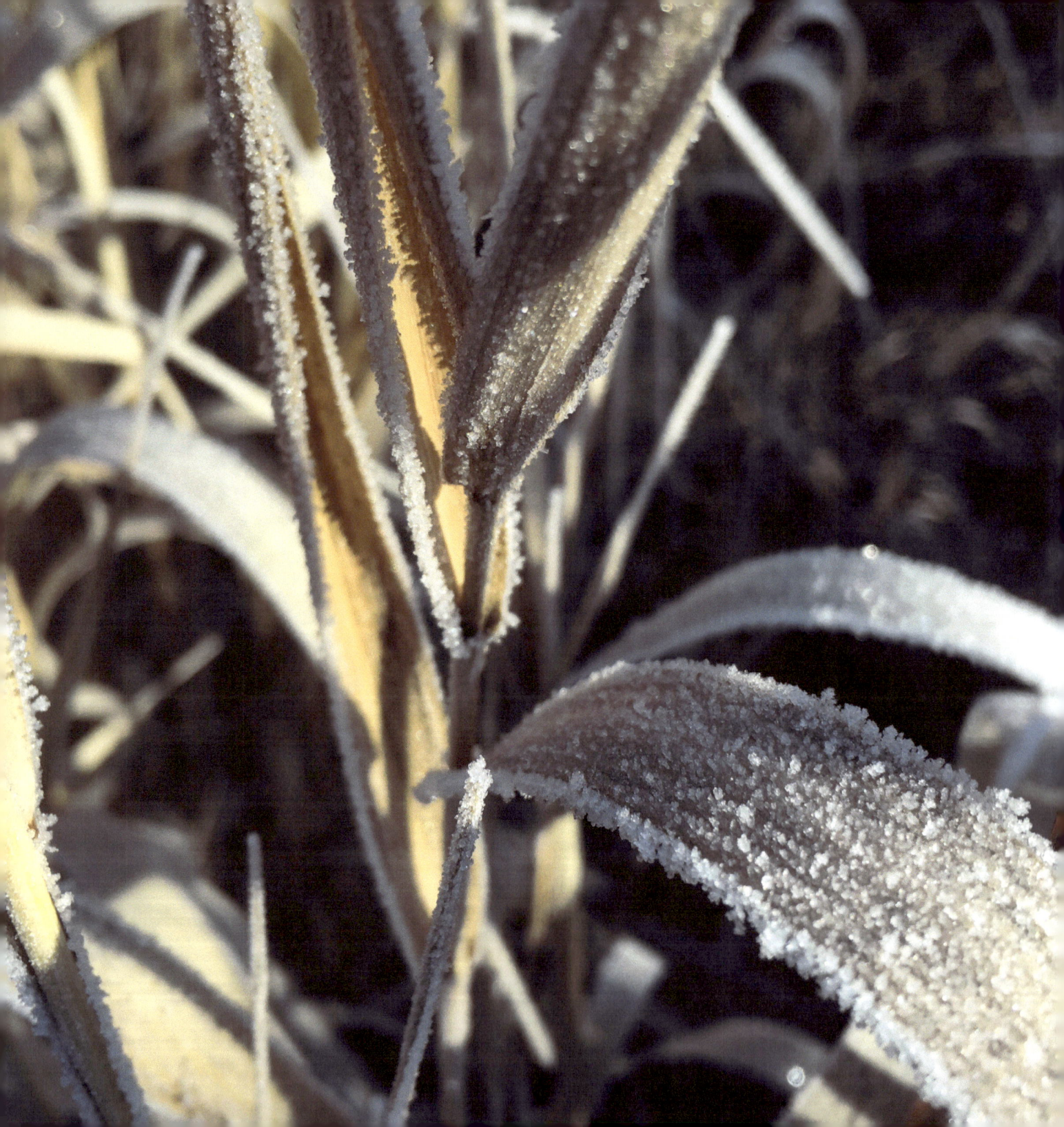

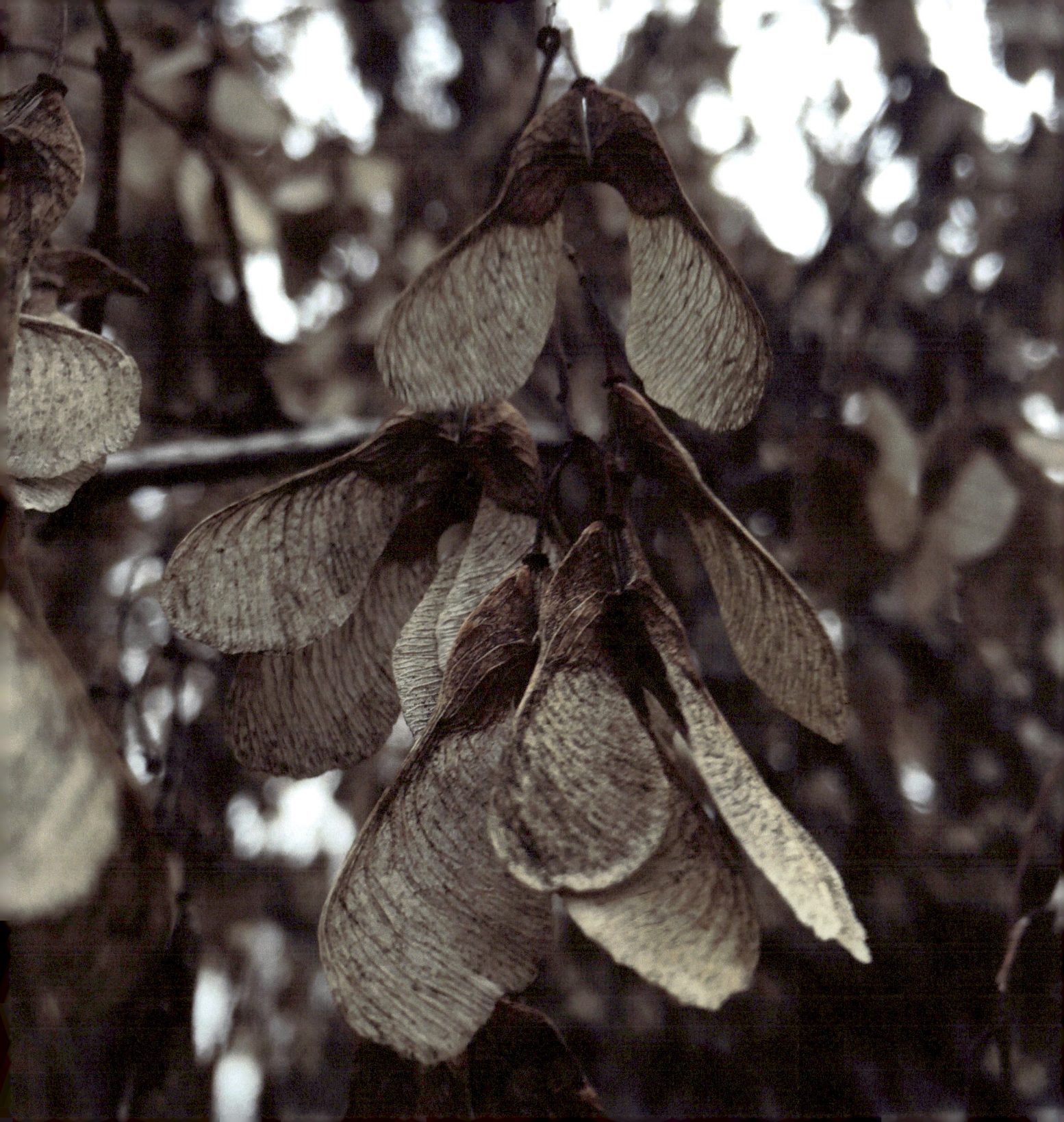

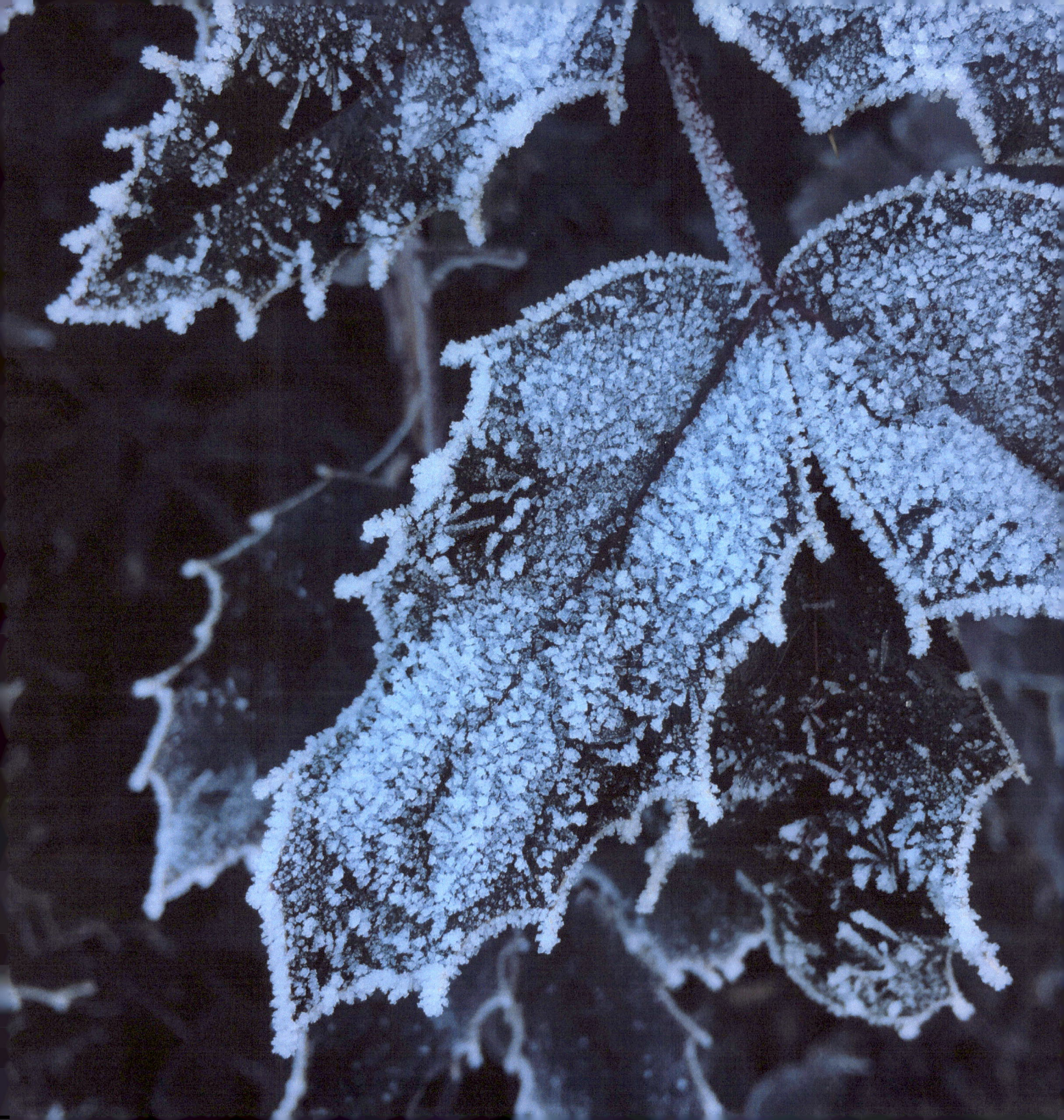

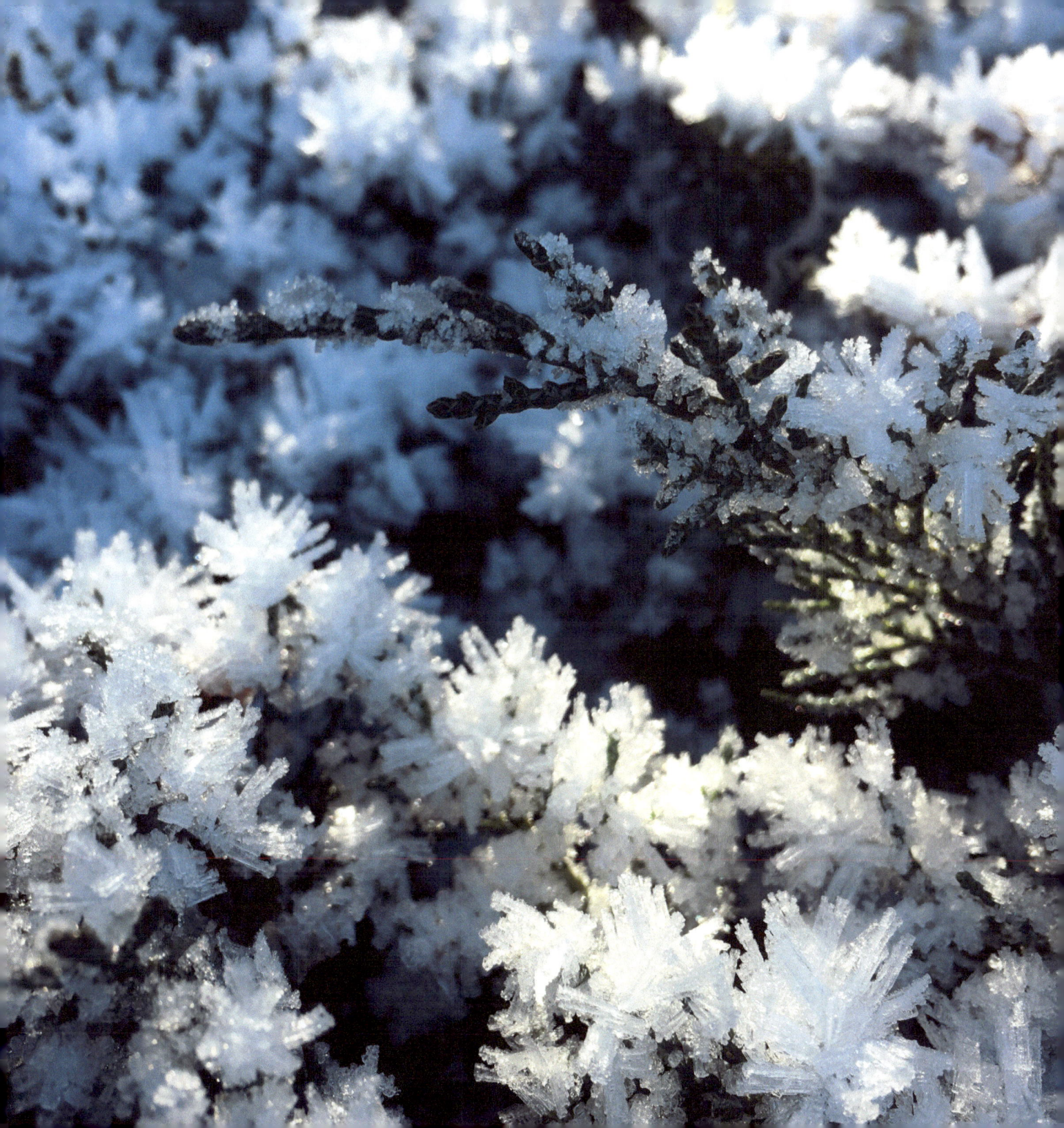

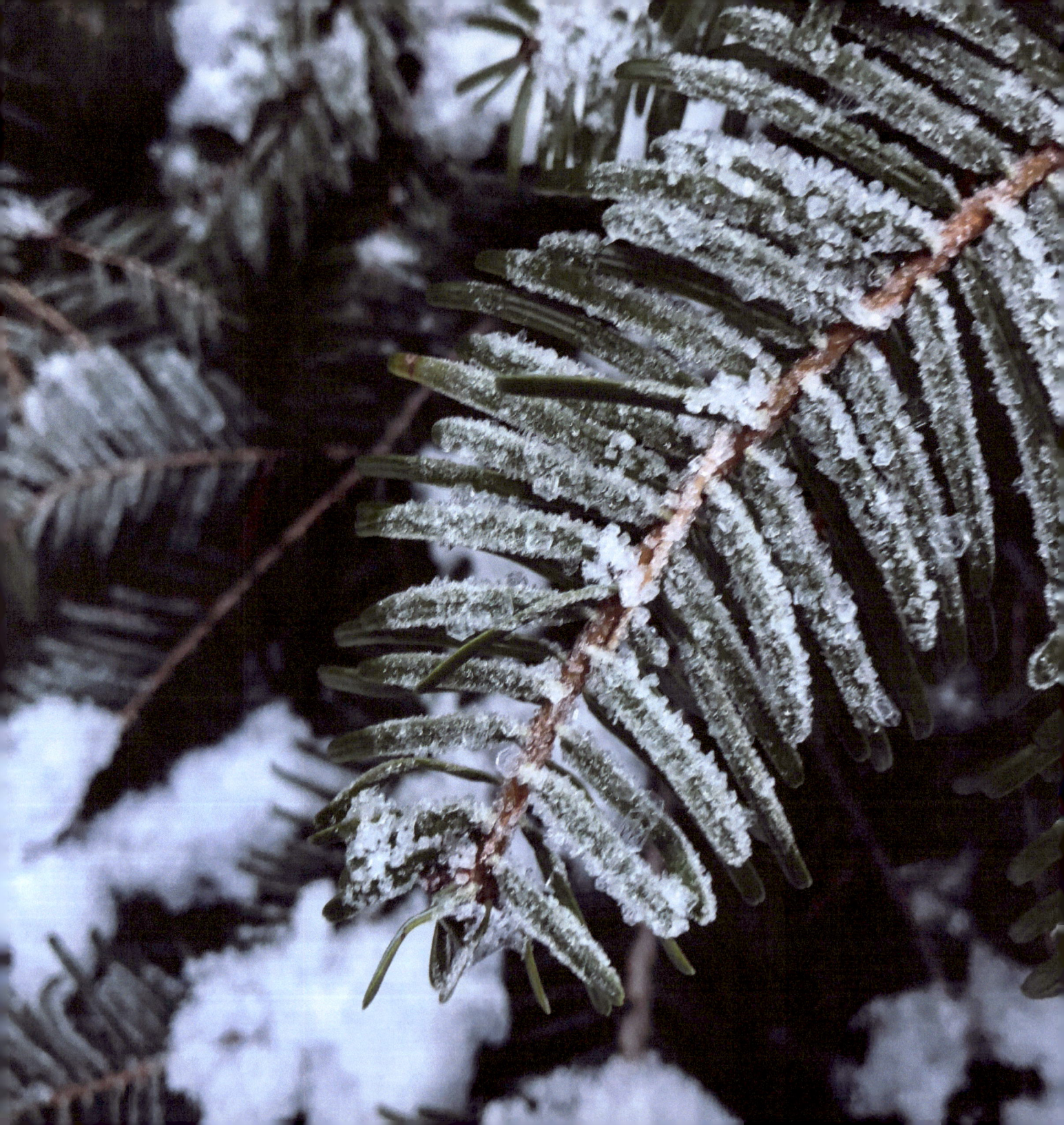

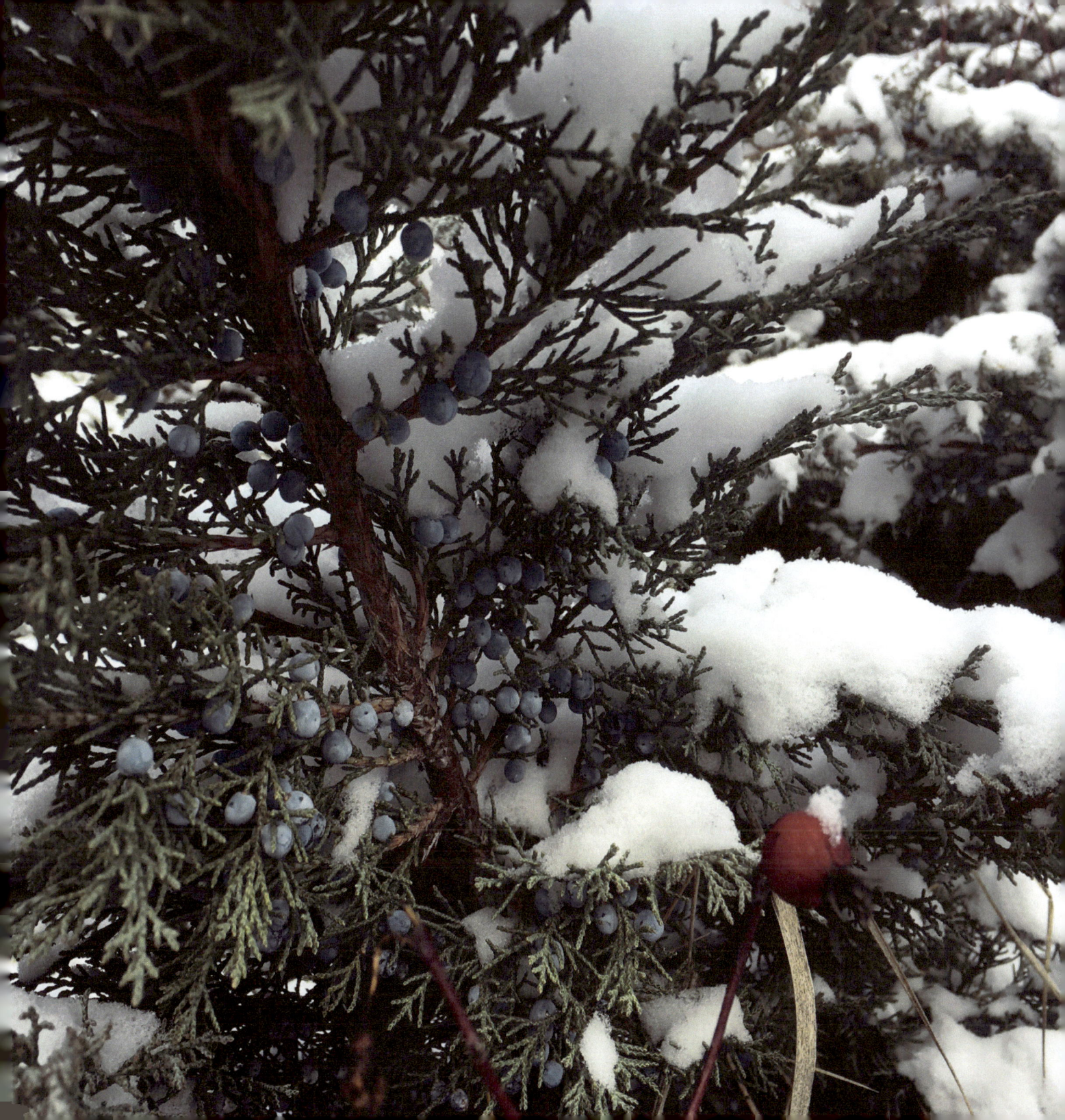

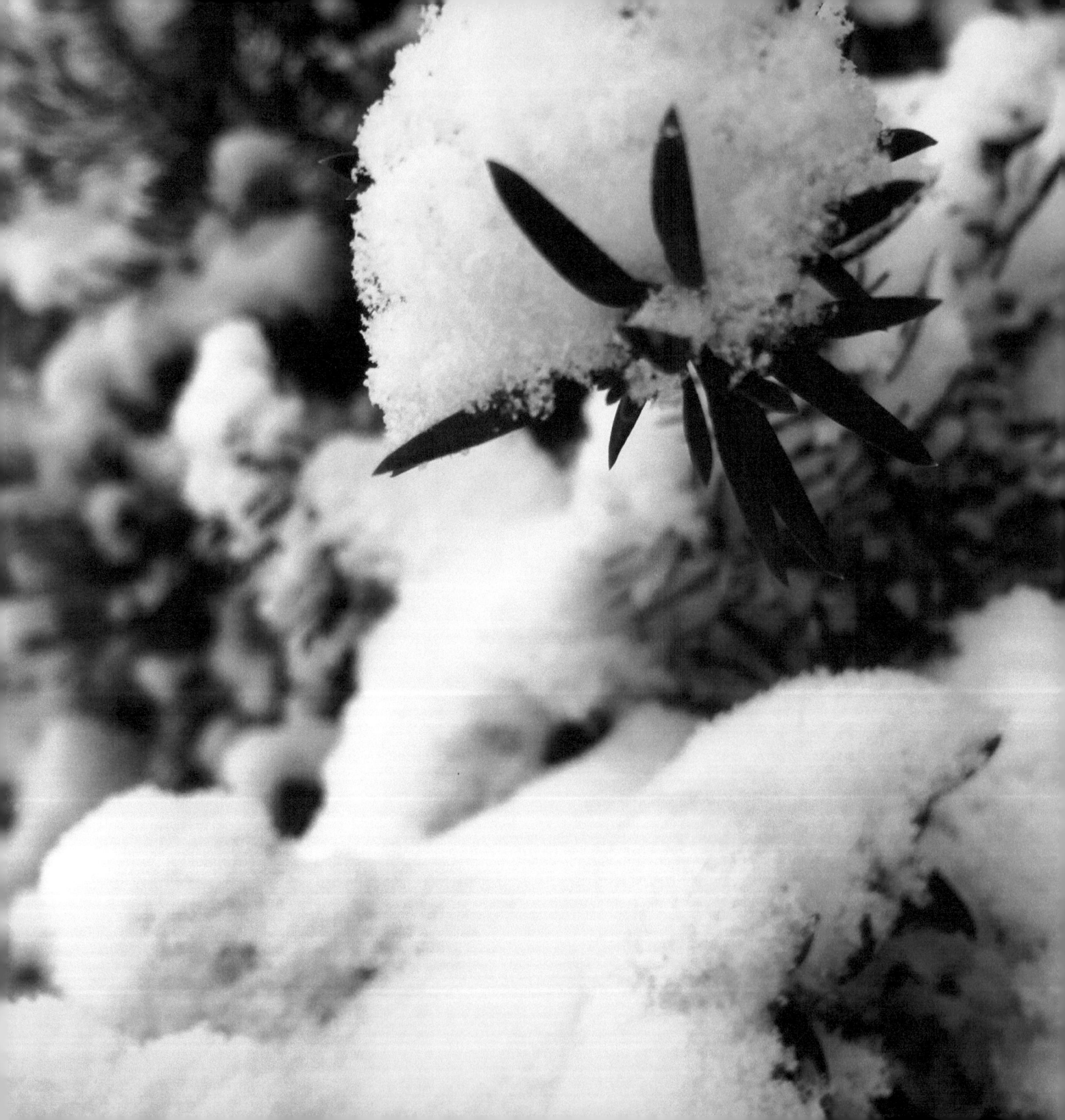

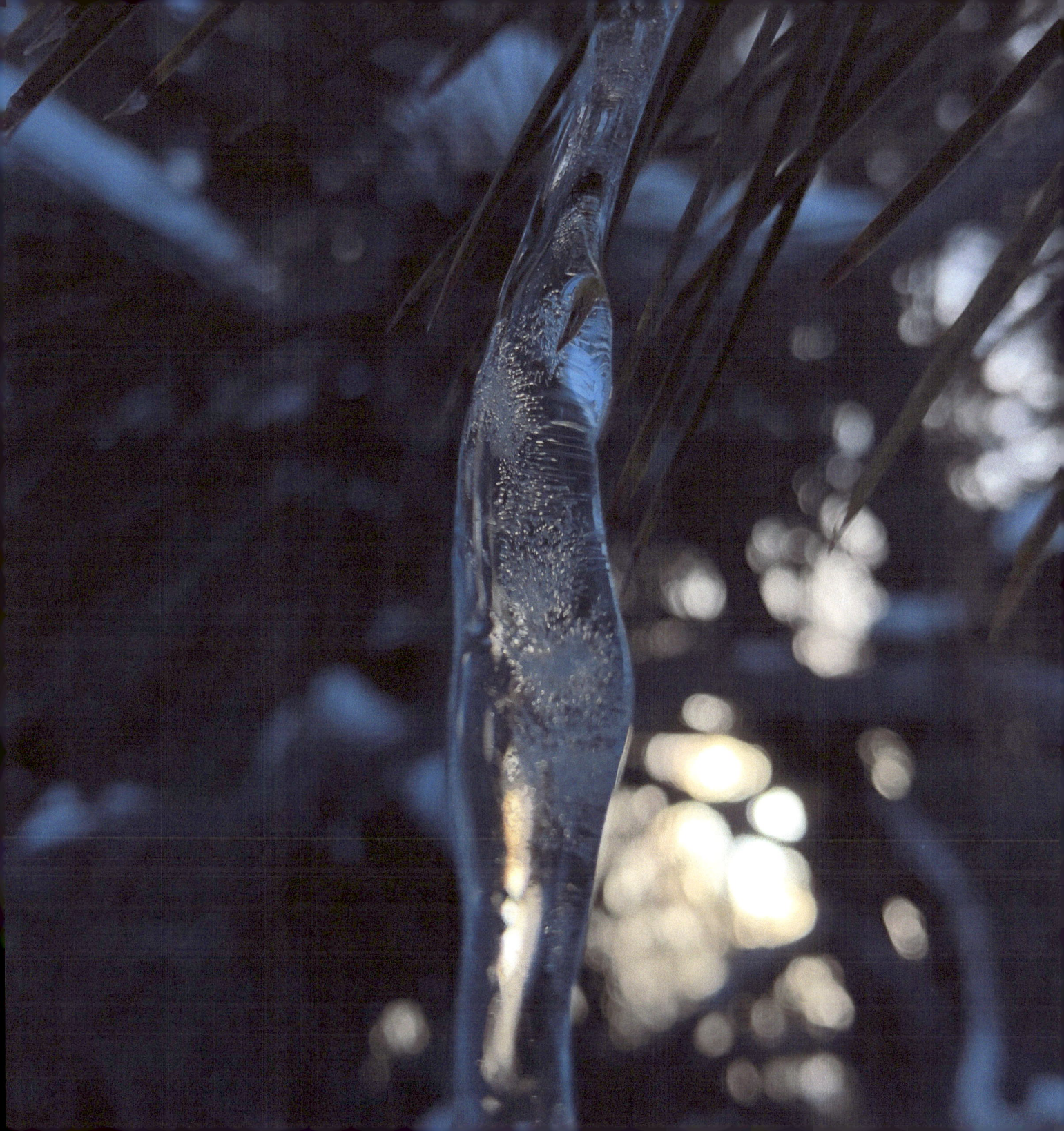

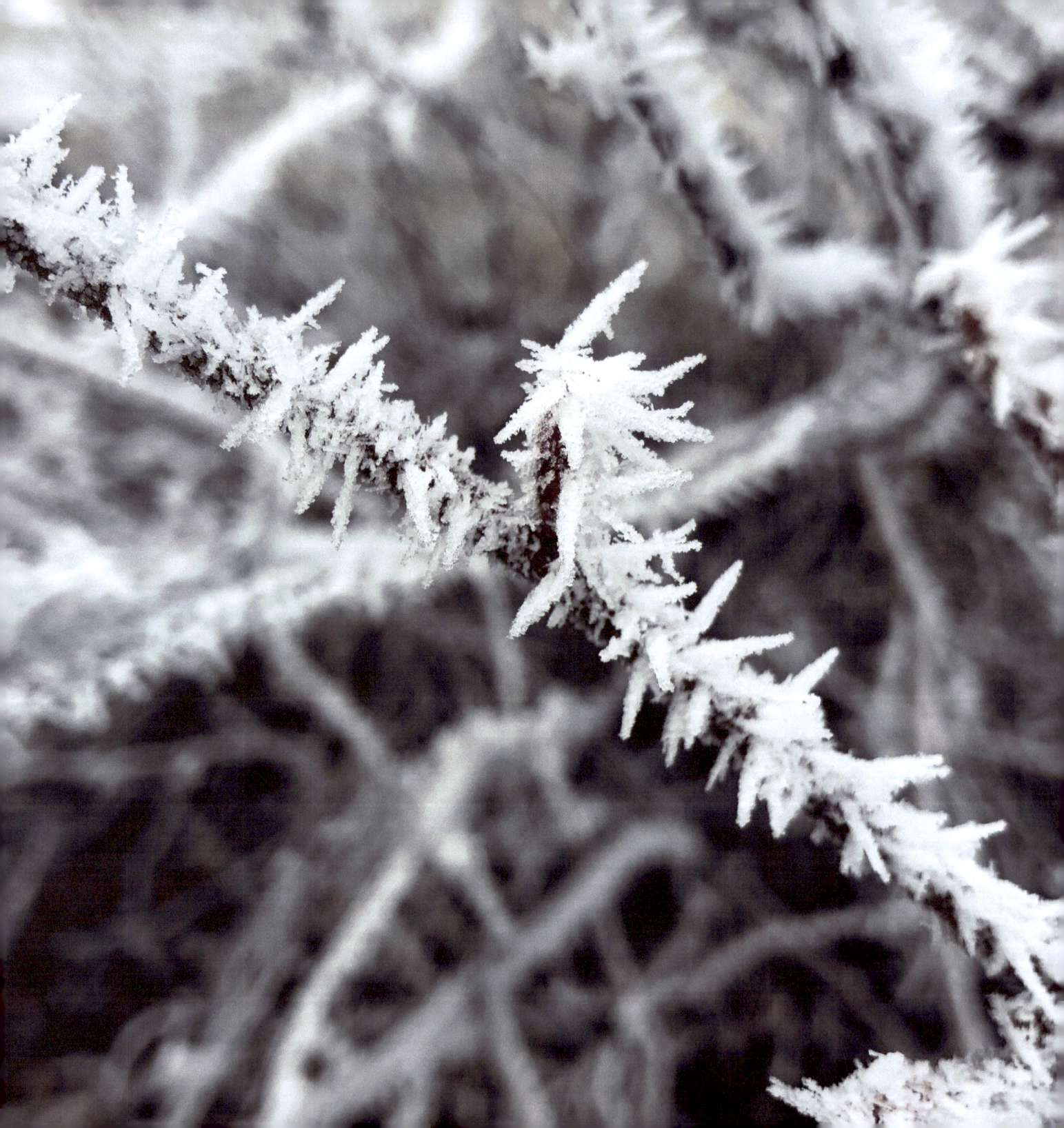

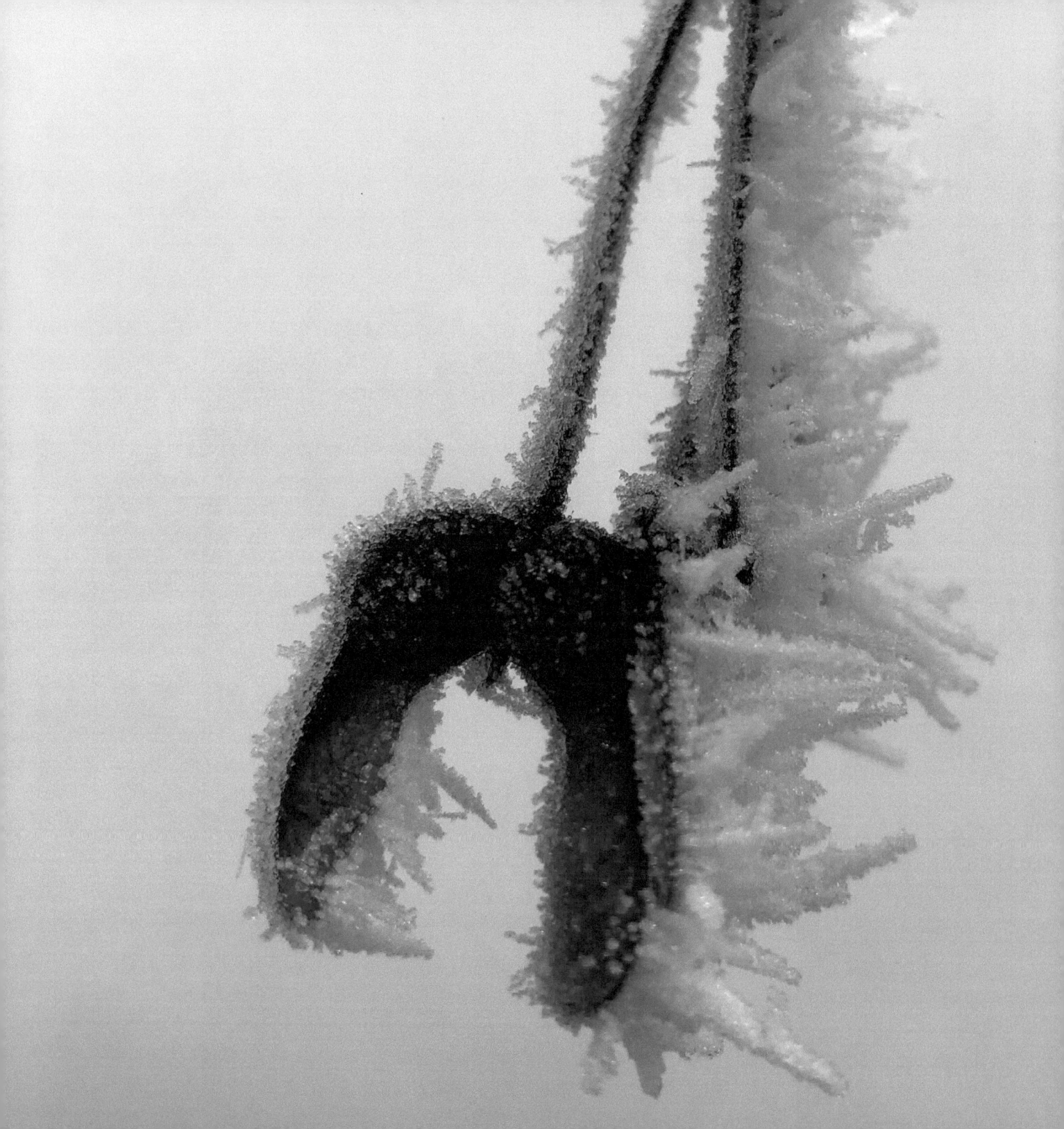

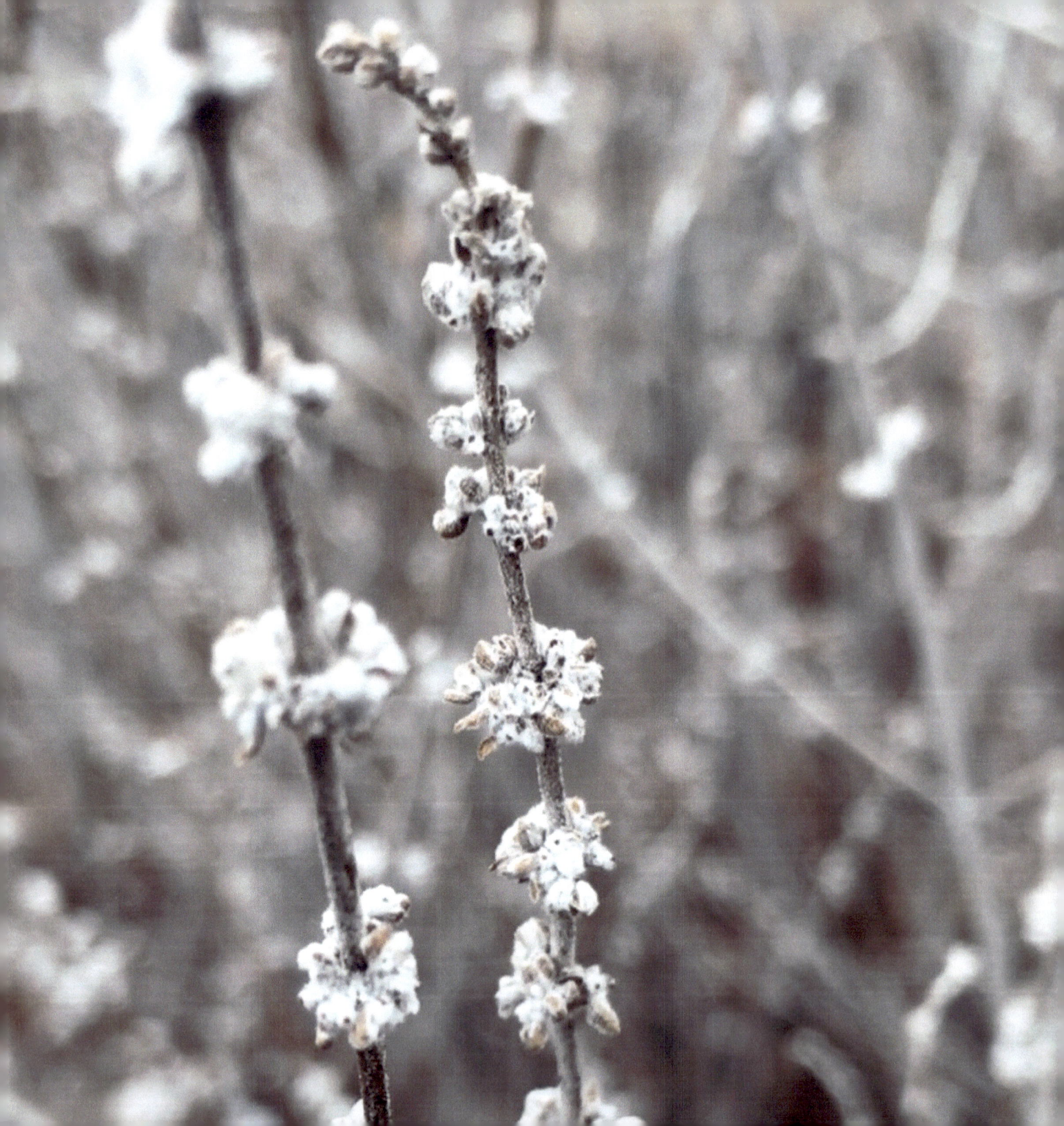

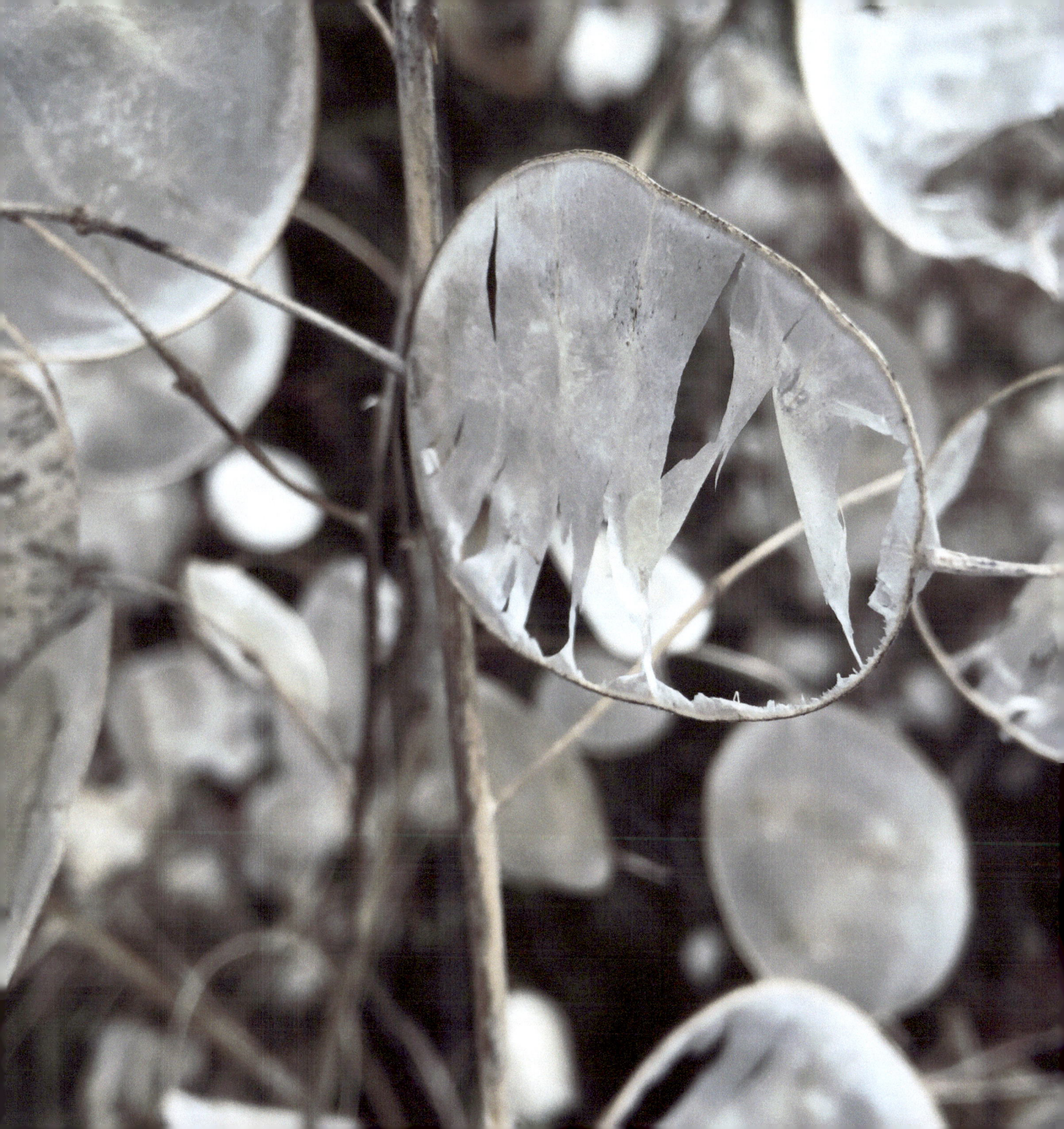

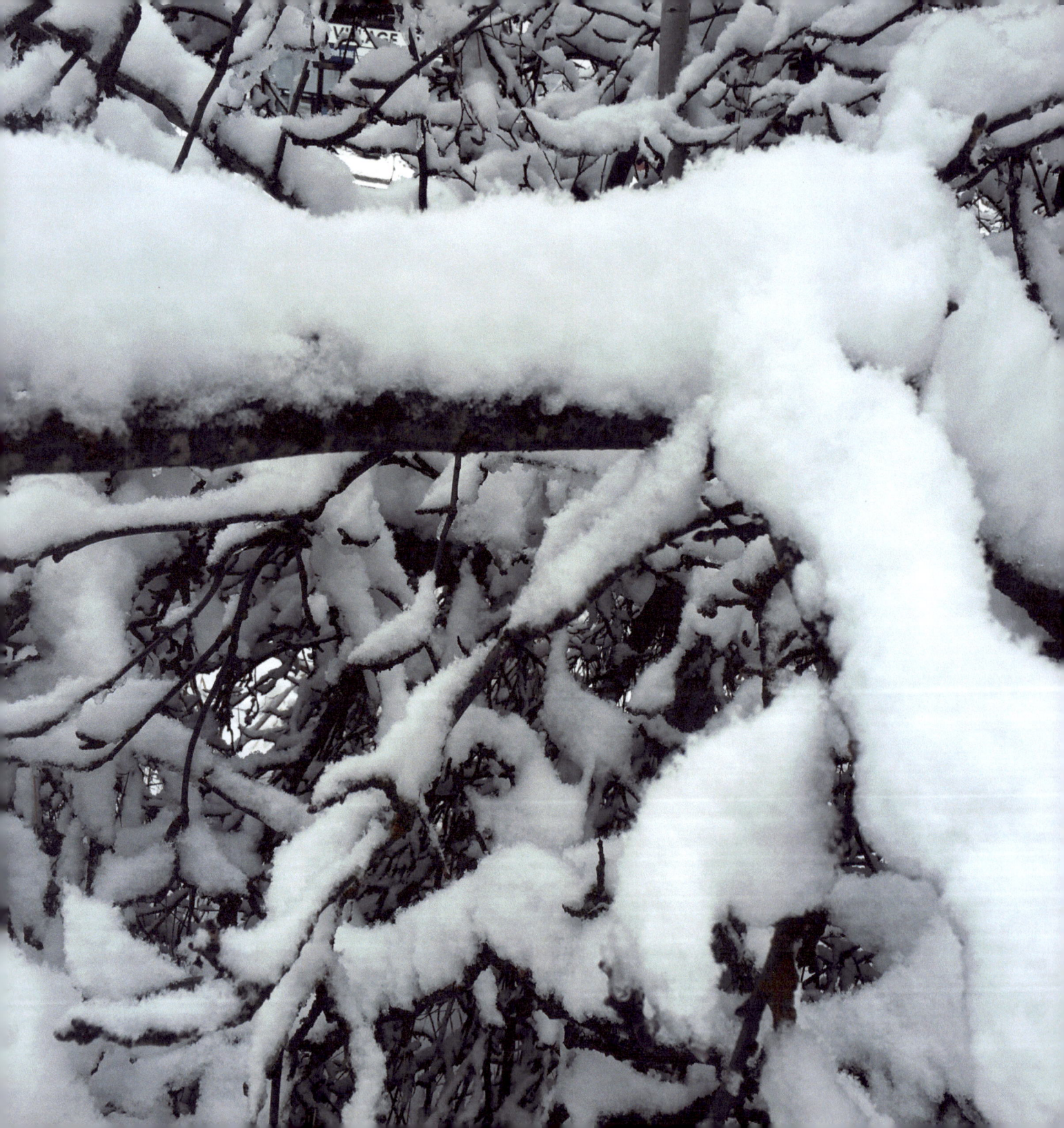

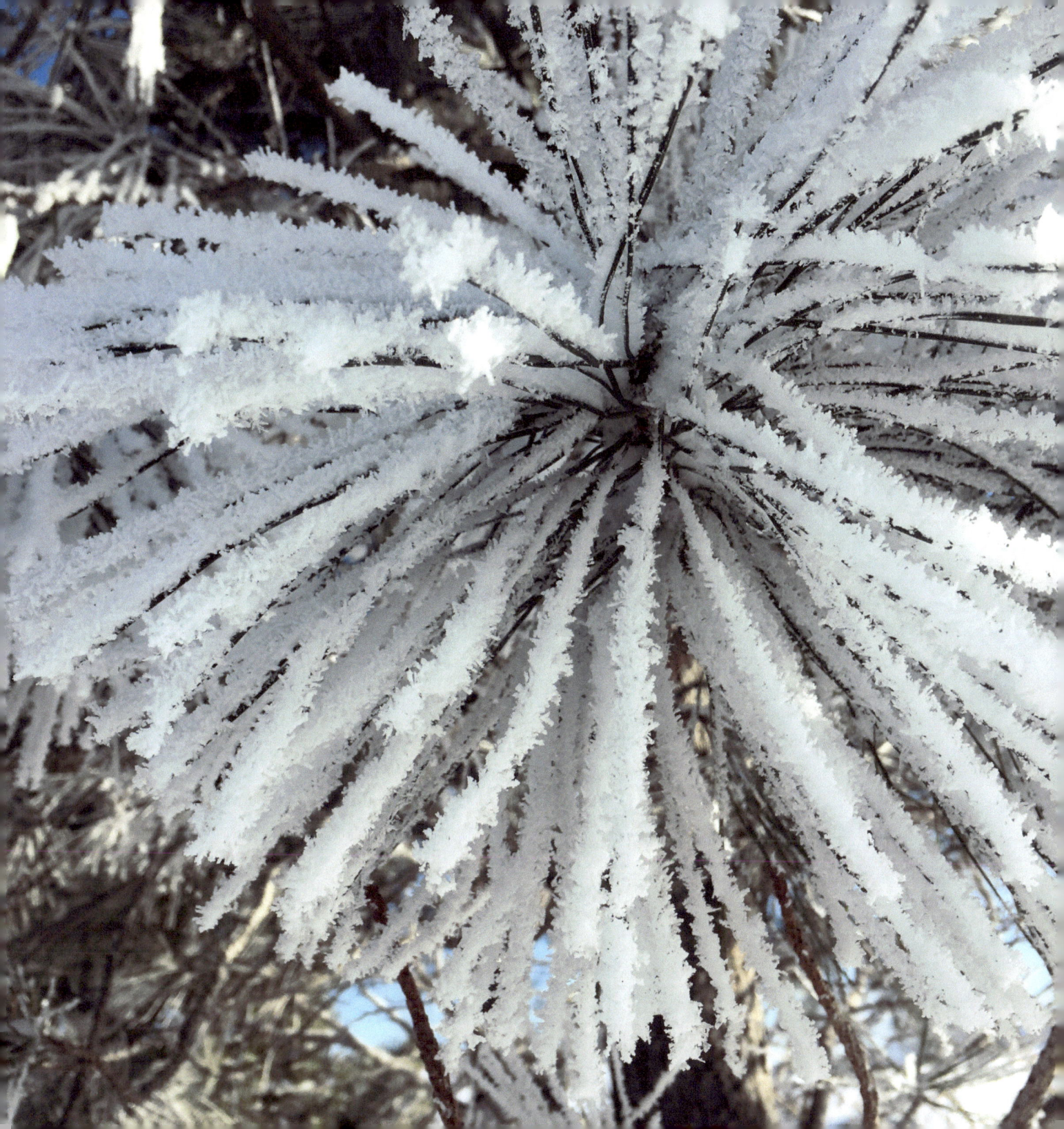

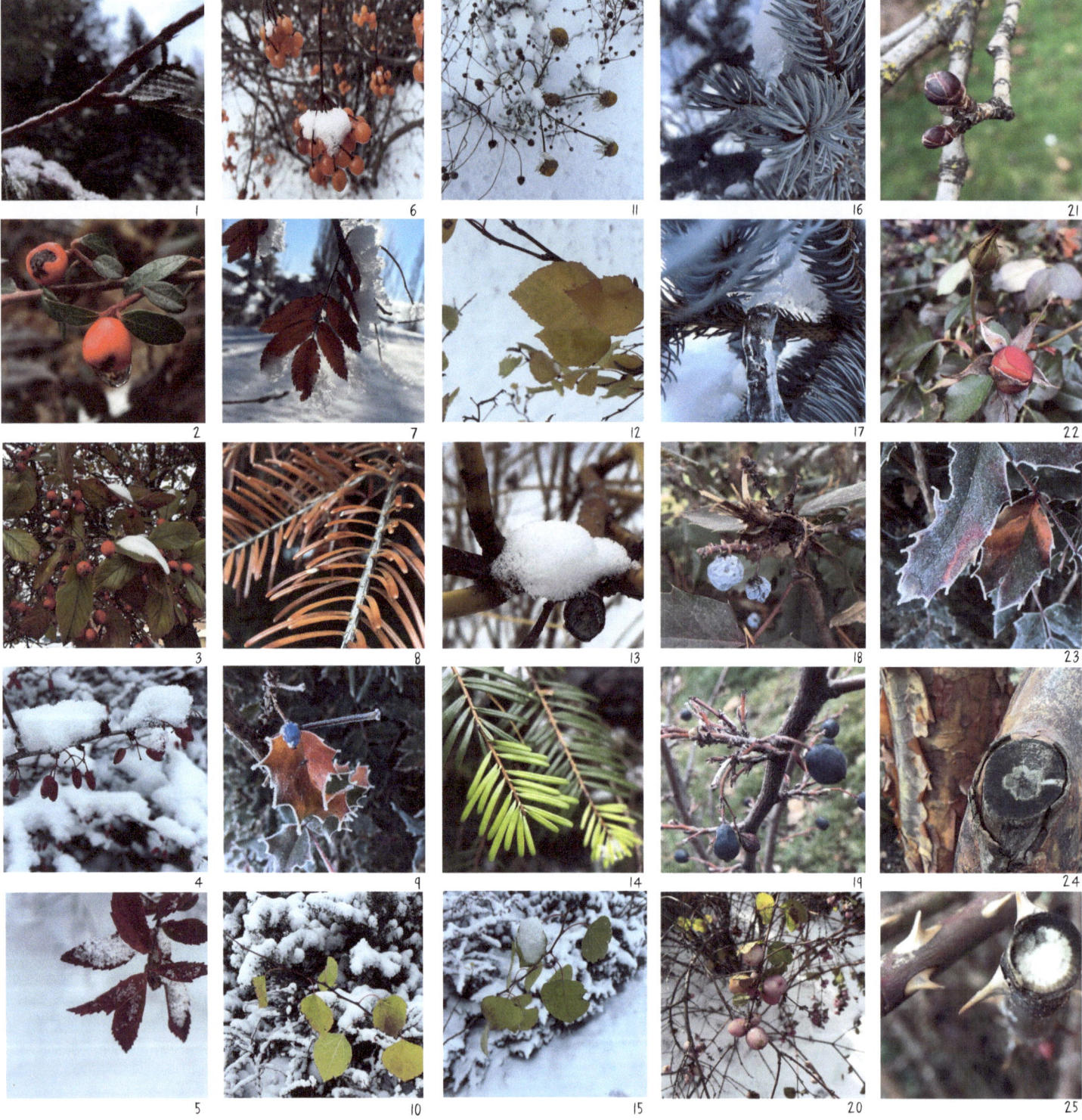

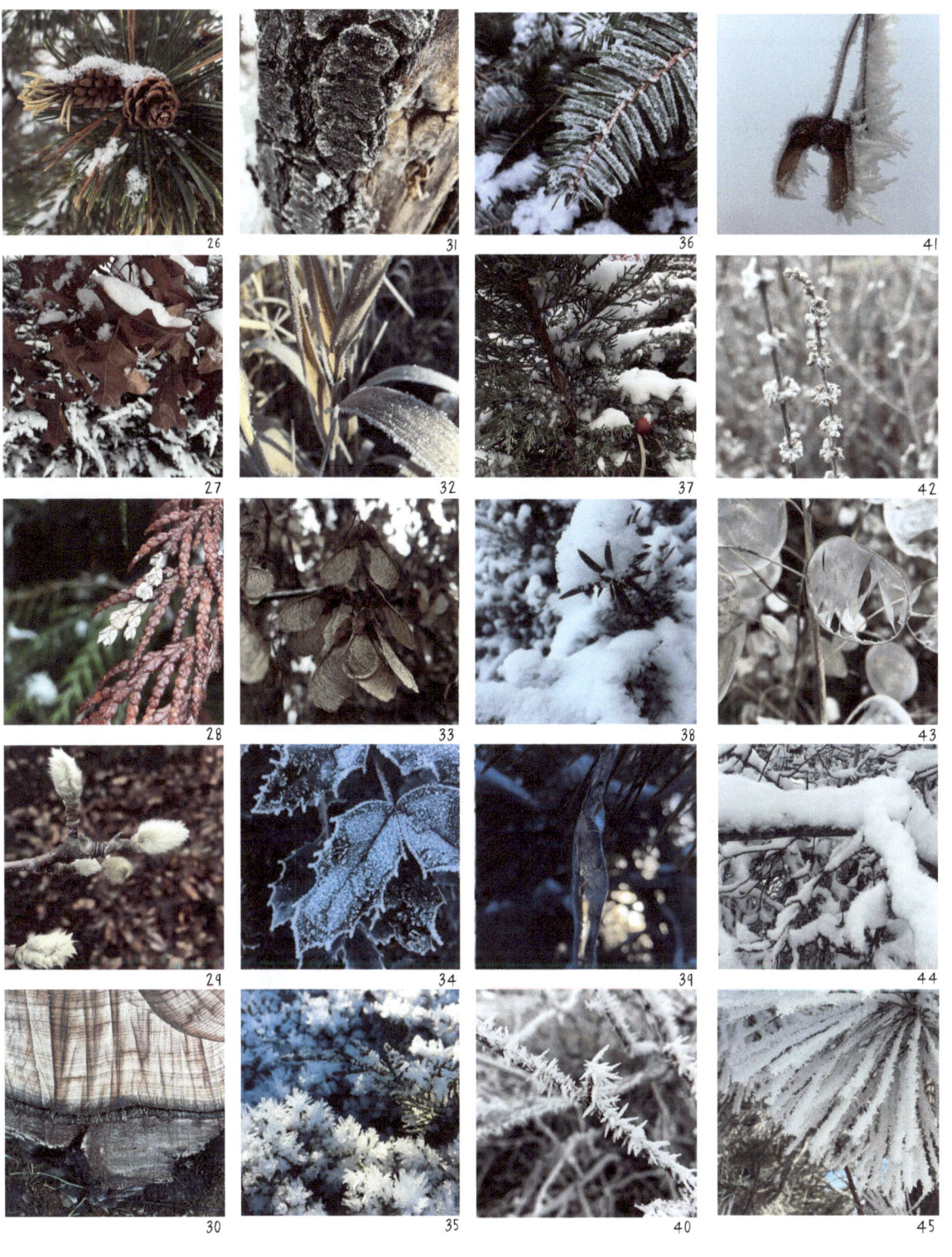

YOUR TURN to find these **winter** characteristics in each of the portrait photos:

pine needles
1, 8, 14, 16, 17, 26, 28, 35, 36, 37, 39, 44, 45

leaves
2, 3, 5, 7, 9, 10, 12, 15, 20, 22, 23, 27, 32, 34, 38, 40

buds
21, 22, 38

berries
2, 6, 9, 18, 19, 20, 37

seed pods
29, 33, 41, 43

snow
4, 5, 6, 10, 11, 12, 13, 15, 17, 20, 26, 27, 36, 37, 38, 39, 41, 44

frost
1, 9, 23, 31, 32, 34, 35, 40, 41, 45

bark
24, 30, 31

pinecones
26

branches
1, 2, 4, 13, 16, 18, 29, 40, 41, 44, 45

thorns
25

icicles
17, 39

flowers
2, 11, 42

So now, YOU go & capture the **faces, characteristics** and **portraits** of nature that you see around you. I wish you well on your journey & may you start to see life in a new way.

www.ingramcontent.com/pod-product-compliance
Lightning Source LLC
Chambersburg PA
CBHW041316180526
45172CB00004B/1117